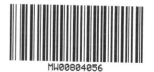

Rediscovering
S. P. Rolt Triscott

Monhegan Island Artist
and Photographer

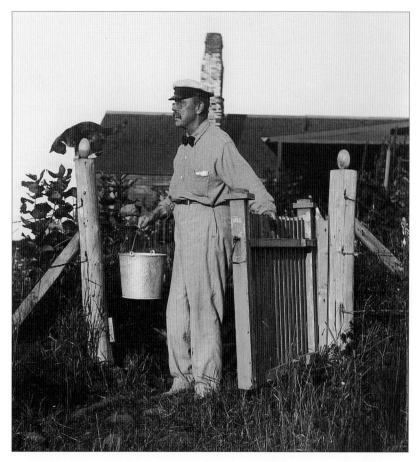

S. P. Rolt Triscott at his garden gate, with one of his cats.
Courtesy of the Monhegan Museum

Rediscovering S. P. Rolt Triscott

Monhegan Island Artist and Photographer

Richard H. Malone &
Earle G. Shettleworth, Jr.

Tilbury House Publishers • Gardiner, Maine
The Monhegan Museum • Monhegan Island, Maine

Tilbury House, Publishers
2 Mechanic Street
Gardiner, Maine 04345
800-582-1899
www.tilburyhouse.com

The Monhegan Museum
Monhegan Island, Maine 04852
207–596–7003

First Edition July 2002

10 9 8 7 6 5 4 3 2 1

Library of Congress Cataloging-in-Publication Data
Malone, Richard H., 1930-1992.
 Rediscovering S. P. Rolt Triscott : Monhegan Island artist and photographer / by Richard H. Malone and Earle G. Shettleworth, Jr.-- 1st ed.
 p. cm.
 ISBN 0-88448-240-5 (pbk. : alk. paper)
 1. Triscott, S. P. Rolt (Samuel Peter Rolt), 1846–1925. 2. Monhegan Island (Me.)--In art. I. Triscott, S. P. Rolt (Samuel Peter Rolt), 1846-1925. II. Shettleworth, Earle G. III. Title.
 N6537.T6797 M35 2002
 760'.092--dc21 2002001625

Cover and Text Design: Edith Allard, Crummett Mountain Design, Somerville, Maine
Editing and Production: Jennifer Elliott and Barbara Diamond
Layout: Nina DeGraff, Basil Hill Graphics, Somerville, Maine
Scans and Film: Integrated Composition Systems, Spokane, Washington
Text Printing: J. S. McCarthy Printers, Augusta, Maine
Cover Printing: The John P. Pow Company, South Boston, Massachusetts
Binding: Acme Bookbinding, Charlestown, Massachusetts

This volume is
dedicated to
Dorothy Malone
who has continued her husband's
commitment to fostering an appreciation
for the art of S. P. Rolt Triscott

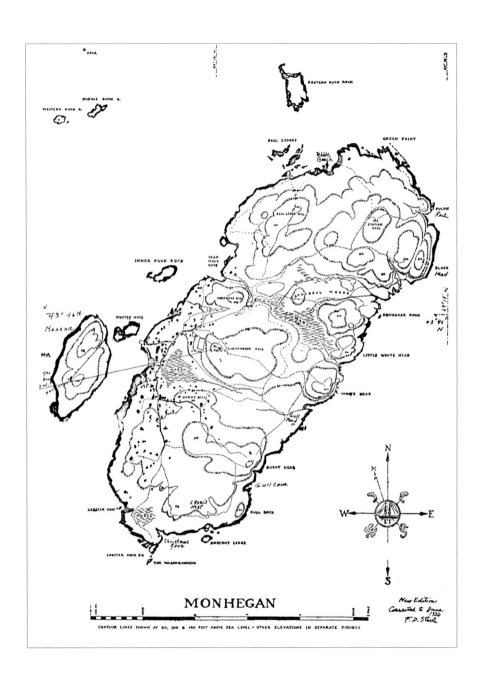

Map by Frederick Dorr Steele, June 1936.

Courtesy of the Monhegan Museum.

Contents

A Gentleman At Sea
THE FIRST RETROSPECTIVE OF THE WORK OF S. P. ROLT TRISCOTT

WHEN I FIRST became interested in Monhegan art twenty-five years ago, the name Triscott quickly surfaced even though he had been dead for half a century and the art world had all but forgotten his once-famous watercolors. On Monhegan Island, however, there were still people who had known him, his watercolors still hung on the walls of several homes, and he was considered by some locals to have been one of the most important members of Monhegan's celebrated art community.

In the 1880s, British expatriate Samuel Peter Rolt Triscott (1846–1925) was a highly esteemed watercolorist living in Boston. He had emigrated to the United States in 1871, worked as an engineer in Worcester, and spent all his spare time painting watercolors. Eventually, about 1880, he was able to move into Boston, take a studio surrounded by other artists, and devote himself full time to his art. By the time he first visited Monhegan in 1892, along with his student and friend Sears Gallagher (1869–1955), Triscott was at the peak of his career. Enamored of Monhegan's beauty and remoteness, Triscott returned regularly during the subsequent decade, observing the island in both summer and winter, and recording his observations in masterful watercolors and fine-art photographs. In 1902 Triscott gave up his residence in Boston and settled into the Monhegan home he had bought in 1893. From 1902 until his death in 1925 he seldom left the island, although he did occasionally send his watercolors to exhibitions and galleries ashore.

Triscott was a classic nineteenth-century watercolorist in the English tradition. His carefully detailed works, romantically rendered in soft colors with his distinctive washes, were exhibited widely in Boston, New York, and elsewhere during the 1880s and 1890s. The reviews were consistently laudatory, and Triscott clearly enjoyed a place among the small group of top New England watercolorists which also included his friend Winslow Homer (1836–1910), who later would visit him occasionally on Monhegan. When Triscott arrived on the island in 1892, his style had become somewhat freer and his motifs began shifting to include Monhegan's ocean and fishermen as central elements. He became well established among the group of artists who were frequenting Monhegan at that time, and his work is often compared favorably with that of other accomplished Monhegan watercolorists of the era, including not only Gallagher, who was becoming increasingly recognized during the 1890s and early 1900s, but also Alfred Thompson Bricher (1837–1908), Frank Myrick (1856–1917), Charles Copeland (1858–1945), and Monhegan's first two women artists, Maud Briggs Knowlton (1870–1956) and Alice Swett (1846–1916).

While Triscott lived on Monhegan, taste in American art was rapidly changing. Painters of the Ashcan School such as Robert Henri (1865–1929) and George Bellows (1883–1925), American impressionists such as Edward Willis Redfield (1869–1965) and Charles Ebert (1873–1959), expressionists such as Eric Hudson (1862–1932),

and modernists such as Andrew Dasburg (1887–1979) and Maurice Sterne (1878–1957) had a presence on Monhegan during the period from 1903 to 1920. Nationally, work by members of these movements dominated the American art scene. Nonetheless, Triscott's style remained consistent, and his output of watercolors continued even as they were receiving less and less attention. In the years following his death, the many works that remained in his estate were sufficiently out of fashion that they were given away or sold for just a few dollars apiece. Only recently have a few collectors, dealers, and museums begun, once again, to take notice of Triscott's long-forgotten watercolors, appreciating not only the exceptional technique but also his sensitive portrayal of land and sea.

Both the publication of this book and the exhibition it accompanies celebrate the centenary of Triscott's becoming the first artist to live as a permanent, year-round resident of Monhegan, thus giving him a unique status within the early twentieth-century island community. Known to the island's fishermen, children, innkeepers, and rusticators (as the summer people were then called), Triscott was a somewhat reclusive gentleman who was cordial to all. A few islanders and artists even became his good friends, and with them Triscott would often take afternoon tea, which, when held at his home, was served from his silver tea service, reflecting his English background.

We at the Monhegan Museum are excited to have arranged an exhibition of the life and art of S. P. Rolt Triscott. The exhibit will be held at the Monhegan Museum from July 1 to September 30, 2002. It will then travel to the Portland Museum of Art. It includes not only his watercolors, but also photographs that Triscott himself printed, as well as a sampling of his hand-tinted photographs and his oil paintings. Few oils by him have been located, and records suggest that there were but a small number. It is thus surprising how truly accomplished they are.

The exhibition, along with this book, constitutes the first retrospective of Triscott's work and provides the first opportunity in decades for a wider audience to experience the range and quality of his vision of the Maine Coast, particularly Monhegan Island.

Many people deserve thanks for helping with this project. Tralice Peck Bracy, curator of the Monhegan Museum, created the Monhegan exhibition. Jessica Nicoll, chief curator of the Portland Museum, collaborated on the project and curated the Portland exhibition. Earle G. Shettleworth, Jr., director of the Maine Historic Preservation Commission, not only produced this book but also did considerable work to make the exhibition possible.

We especially thank Dorothy Malone for her loan of many of the watercolors in the exhibition and for the care she has taken in preserving the research materials and writings compiled by her late husband, Richard, back in the 1970s when it seemed that he alone recognized the importance of Triscott's life and work. We also thank Nancy Malone Appleton, Sheila Koughan, Keith P. Malone, Jackie Boegel and Bill Boynton, Thomas Hinkle, Remak Ramsay, Sally W. Rand, Earle Shettleworth, and Jamie Wyeth for loaning watercolors to the exhibit.

Finally, publication of this book was made possible by financial contributions from the Davis Family Foundation and Robert and Carol Stahl, and from Marion Wheeler and Marilee Wheeler (in memory of Jacqueline Hudson). We are extremely grateful.

Edward L. Deci, President
Monhegan Museum Association

Introduction
and Acknowledgements

I FIRST BECAME AWARE of the watercolors and photographs of S. P. Rolt Triscott in 1992 while seeking information about Monhegan Island photographers. That year the Maine Historic Preservation Commission acquired a collection of late nineteenth-century photographs of the island by Edward Robinson of Thomaston, and this lead me to the Monhegan Museum. While the museum owned several of Triscott's paintings, he was represented in the photograph collection by only one box of glass negatives and a few original prints. The quality of his work made me want to see more, but at that point nothing else was known to have survived.

That trip to Monhegan produced the discovery of the wonderful collection of artist Eric Hudson's glass negatives, which resulted in the 1998 publication *An Eye for the Coast* by William H. Bunting and myself. It was Hudson who brought me back to Triscott. In putting the final touches on captions for the Hudson book, Bill Bunting wanted to interview retired lobsterman Norman Davis of New Harbor, whose father Manville Davis had been a great source of information about fishing and lobstering on Monhegan. Bill suggested that I join him because he recalled having seen Davis family photographs of Monhegan on a previous visit.

On an afternoon early in 1998, Bill Bunting and I called on Norman Davis. While Norman answered Bill's questions, I looked through several photograph albums which had been assembled by Norman's aunt Josephine Davis Townsend. Here and there amid the myriad personal snapshots from the 1920s, '30s, and '40s were striking contact prints of 5- by 7-inch glass negatives of Monhegan scenes of an earlier vintage, which I recognized as Triscott's work. Containing my excitement, it was now my turn to query Norman. Yes, these were prints from Triscott's negatives which had been made by Josephine Townsend shortly after Triscott died in 1925. She had assisted Triscott in printing and coloring his photographs in his later years, and she had acquired his photographic equipment and negatives after his death. The question of whether the negatives had been preserved met with an uncertain response from Norman, who thought that they may have been lost sometime after his aunt's death in 1981. At that point I had to content myself with the thirty contact prints which Norman let me borrow to copy. My knowledge of Triscott as a photographer had expanded, but the body of his work remained small. This was soon to change.

Sadly, Norman Davis passed away in May 1998. In settling his estate, the large collection of Triscott negatives saved by his aunt surfaced and was acquired by the Maine Historic Preservation Commission. Now it was possible to assess the breadth and depth of Triscott's accomplishments as a photographer, and what a rich legacy it was! The extraordinary range and quality of his pictures quickly convinced me that he deserved a book similar to the one Bill and I had done for Eric Hudson. Little did I know how much more complex the matter of discovering Triscott would become.

In 1999 I began my research on Triscott through the usual channels of public records, period newspapers, art reference books, and exhibition and auction catalogues. I soon realized that Triscott had been a major New England

watercolorist in the last two decades of the nineteenth century and that I needed to address his paintings on an equal footing with his photographs. As I sought examples of his watercolors in public and private collections as well as through dealers, I began to hear the names of Richard and Dorothy Malone as the primary collectors of Triscott paintings. From 1971 until his death in 1992, Mr. Malone actively collected Triscott's work, and Mrs. Malone has retained the collection and added to it.

In August 2000, I made an appointment with Dorothy Malone to visit her on the Saturday of the upcoming Labor Day weekend. Nothing could have prepared me for the extraordinary experience of seeing such a large number of Triscott paintings in one morning, many of them major examples of his work. It was the closest one could come to visiting the artist's studio a century ago. After my tour of the collection, Dorothy and I engaged in a long conversation in which she shared with me that her husband's fascination with Triscott had lead him to do extensive research which resulted in a 1979 biographical essay about the artist. As I read through the pages of Richard Malone's typescript, I concluded that it was clearly worthy of publication; and that with my own knowledge of Triscott, I could serve as its editor as well as add a brief chapter on the newfound information about Triscott's photography. Dorothy kindly agreed, and this approach has governed the preparation of the present volume as well as the accompanying Triscott exhibition, which will be held at the Monhegan Museum from July through September, 2002, and then move to the Portland Museum of Art.

To paraphrase Shakespeare, by indirection direction find. My personal journey to rediscover Triscott started on Monhegan Island in 1992 with one box of glass negatives and has taken several unexpected turns before arriving at this book and its companion exhibition of paintings and photographs. Now I can step back and watch others have the pleasure of rediscovering S. P. Rolt Triscott.

I am indebted to several individuals for making this book and its accompanying exhibition possible. Foremost among them is Dorothy Malone, who graciously shared her husband's extensive Triscott research with me as well as their impressive painting collection. Richard Malone's remarkable essay on the artist's life and work provides the principal text for this volume. Edward Deci, president of the Monhegan Museum, has been wonderfully supportive at every step of the project. Likewise the curators of the Monhegan Museum and the Portland Museum of Art, Tralice Peck Bracy and Jessica Nicoll, have been a pleasure to work with in planning the exhibit.

For their valuable assistance in locating Triscott paintings and photographs, I wish to acknowledge the following dealers: James Arsenault, Annette and Rob Elowitch, Dennis Gleason, Jake Gillison, Keith Oehmig, and Jeffrey Robinson.

The photographic prints from Triscott's glass plate negatives were made with great care by David Miskin and Joseph Kolko at Just Black and White in Portland. In identifying these photographs, I was assisted by William H. Bunting, Ed Deci, Sally W. Rand, and the late Jacqueline Hudson. Special help came from Ruth Grant Fuller, whose book *Monhegan: Her Houses and Her People, 1780–2000* is a model of its kind.

As the manuscript was readied for publication, Dorothy Malone, Sally W. Rand, and Ed Deci were especially helpful readers. Jennifer Elliott and Barbara Diamond of Tilbury House then applied their editing skills. Finally, Edith Allard transformed text and pictures into the handsome volume now before you.

Earle G. Shettleworth, Jr.

There is a pleasure in the pathless woods,
There is a rapture on the lonely shore,
There is society, where none intrudes,
By the deep Sea, and music in its roar:
I love not Man the less, but Nature more,
From these our interviews, in which I steal
From all I may be or have been before,
To mingle with the Universe, and feel
What I can n'er express, yet cannot all conceal.

FROM "CHILDE HAROLD'S PILGRIMAGE," LORD BYRON

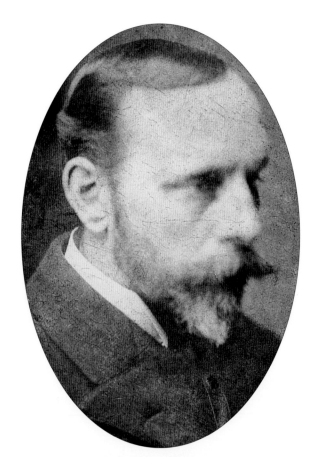

S. P. ROLT TRISCOTT
COURTESY OF THE MAINE HISTORIC PRESERVATION COMMISSION

S. P. ROLT TRISCOTT
by Richard H. Malone

WHEN WILLIAM HOWE DOWNES of the *Boston Evening Transcript* reviewed the Boston Art Club's Forty-Sixth Annual Watercolor Exhibition in 1892, he began: "Certainly the ability of the American painter to make a pretty and satisfactory watercolor has enormously grown in the last decade, and where one man knew how to do it in 1882, an army of men and women can now perform that feat without apparent effort."[1] Although one might imagine that the one man referred to by Downes was Winslow Homer, evidence suggests that it was more likely Samuel Peter Rolt Triscott. Further reading of the 1892 review reveals this interesting statement: "The watercolorists who should shine the brightest in a crowd (such as Childe Hassam, George Smillie, Francis Murphy, S. P. R. Triscott) are easily outstripped by many less-known competitors."[2] This suggests that in 1892 Triscott was considered at the top of his field along with Hassam and others, so it is conceivable that ten years earlier he might have been viewed as the best of them all. Many years later, Triscott's 1925 obituary in the *Boston Globe*, probably written by A. J. Philpott, appears to confirm the artist's high stature in the Boston art world of the time, for it reads in part:

> SAMUEL PETER ROLT TRISCOTT was one of the best-known water-color painters in America 50 years ago. In fact, he may be said to have taught watercolor painting to America, especially what is known as the transparent wash. He had a studio at the corner of Winter and Washington Sts., in Boston, for many years, and there he also had classes in painting which were attended by artists who have since become famous.[3]

Furthermore, the reason Downes placed the emphasis on the year 1882 might best be explained by an examination of contemporary newspaper articles of the day. Winslow Homer held a showing of his Tynemouth watercolors in February 1882 at Chase's

Gallery in Boston. Although the reviews in the Boston and New York papers were appreciative, they lacked the enthusiasm of those written when Homer made another showing of his Tynemouth watercolors twenty-two months later at Doll & Richards in December 1883. The show of watercolors that seems to have made the biggest impression on the *Boston Daily Advertiser*'s art critic during the 1881–82 season was that of Triscott, a relative newcomer to the Boston art scene, who was then holding his first major one-man exhibition at the old gallery of the Boston Art Club between December 20, 1881, and January 7, 1882. Although the review is unsigned, Downes is known to have joined the staff of the *Advertiser* sometime after his stint at the *Globe* in 1878 and the *Sunday Times* in 1879. He remained the *Advertiser*'s art critic until 1887 when he joined the *Transcript*. The following review is written in the same style as many signed by Downes:

MR. TRISCOTT'S WATER COLORS
A special exhibition of water-colors by S. P. R. Triscott was opened on Tuesday at the Boston Art Club Galleries, and will continue until January 7. This is the first exhibition Mr. Triscott has made here, we believe, but it is to be hoped it will not be the last, for it is the best thing in the way of pure water-colors that has been done in this city for years. There are no less than 156 numbers in the catalogue, with 15 black-and-white drawings besides. Almost every example is good, and a very pleasant hour may be spent in making the rounds of the gallery. The pictures are landscapes, and a large proportion of them are of New England scenery, though there are a few English subjects, and some are coast scenes from the Provinces. In color they are simply delicious, and an unfailing good taste shown in the choice of compositions. Mr. Triscott does not share the delusion common among American aquarellists that all sorts of subjects are

equally susceptible of adequate treatment by water-colors; it is evident at the first glance that he knows the limitations as well as the capabilities of his medium, and governs himself accordingly. The atmospheric qualities of most of his works are very fine. His use of light, fresh greens in foliage and grass lends a captivating flavor of morning and springtime to many of his pictures. His impressions are translated with honesty, and they are marked by extraordinary refinement. His methods are those of the most punctilious water-colorist, and the best effects are accomplished with the simplest means, pure washes, without any body color....[4]

Another significant event was the Boston Art Club's Twenty-Sixth Annual Watercolor Exhibition held between April 28 and May 27, 1882, in which Triscott showed four works, the most important being a large picture, *A Wild Moor,* illustrated in the catalogue. This watercolor was referred to several times the following year by Boston art critics and received the following exemplary review in the *Boston Globe* of April 30, 1882:

A Wild Moor by S. P. R. Trescott [*sic*] is the best that this artist has shown for some time, and well deserves the honorable place which has been given it. It is a lonely stretch of moorland with earth and sky flushed with the darkening after-sunset light and a single night bird wheeling in upward circles near the earth. The simple majesty of conception and treatment, the spell of loneliness which the artist has given so well, the sympathy with which he has entered into the spirit of the scene, mark it as one of the most important pictures of the exhibition.[5]

Homer showed several of his Tynemouth watercolors at this show, but they were not mentioned by the *Globe* reviewer. This is not surprising, for most historians feel that Homer's watercolors did not attain their greatest strength until after the winter of 1881–82.

In later Boston newspaper articles, Triscott is given credit for teaching Homer watercolor painting. Other evidence makes a case for this having happened during the winter of 1881–82.[6]

Many reviews of Triscott's work exhibited more praise than one would attribute to mere politeness or to a general promotion of the art world. Reviews of this era often fell into the category of damning with faint praise, but contemporary appreciation of Triscott was of the highest degree. A critic for the *Chicago Times Herald* spoke glowingly of the artist in 1899:

> S. P. R. Triscott is pronounced by many critics the most able aquarellist in America. A collection of his works may now be seen at the O'Brien Gallery. The subjects are chiefly descriptive scenes about his home on Monhegan Island. Mr. Triscott's admirers, and he has many, will discover a great improvement in his style. His brushwork is broad, full. His draughtsmanship is excellent, and he is possessed of uncommon versatility and endowed with a fund of imagination. He is a master of the brush, daring but always sane. Mr. Triscott of late has been making a careful study of winter, and a number of scenes described were painted almost wholly out-of-doors. *Early Winter* is full of charm with its hamlet of ugly houses, the blue bay beyond, and further on a promontory of saffron hills and a glimpse of gray sea—all bathed in the opalescent light of declining day. It is exquisite in tone and atmospheric qualities, *Early Winter* was exhibited at last year's water color exhibition in New York and it lost the Evans prize by one vote.[7]

Samuel Peter Rolt Triscott was born at 23 Cold Harbor, Gosport, England, January 4, 1846, the son of Lieutenant William Elworthy Triscott of the Royal Navy and Harriet Rolt Triscott. Gosport lies across the harbor from the naval base at Portsmouth. Triscott's father entered the British navy as a mate at the age of six-

teen in 1827 and retired as a captain in 1864. His mother was descended from the distinguished Bedfordshire family of Rolts, whose pedigree dated to the twelfth century, and whose members included the eighteenth-century author Richard Rolt. The marriage of William and Harriet Triscott in 1840 produced five sons, of whom Samuel was the third.

Samuel Triscott received a genteel, middle-class upbringing, being given a private-school education and professional training as a civil engineer.[8] He also studied painting with the watercolor artist Philip Mitchell and at the Royal Institute of Painters in Water Colors in London.[9] As the middle son, Samuel had no prospects for family inheritance, so in 1871, at the age of twenty-five, he joined the swelling numbers of emigrants bound for greater opportunities in America. Liverpool, with its sprawling seven miles of docks, was the departure point for the SS China, and on March 9 it arrived in New York carrying Triscott and his fellow engineer George A. Wheeler, along with Wheeler's wife.[10]

Shortly after his arrival in America, Triscott appeared in the Worcester, Massachusetts, city directory as a partner in the fledgling civil-engineering firm of Wheeler and Triscott. The partnership with Wheeler was short-lived, but Triscott continued to work as a surveyor in Worcester, and in 1874 began selling paintings from his office. Although engineering apparently was not the vocation of his choice, he continued to work in this field until he became established as an artist.

During the 1870s, Triscott's surveying duties took him throughout New England, and he surveyed a good part of Massachusetts for road maps. Triscott seized upon this opportunity to paint from nature in locations ranging from Pomfret, Connecticut, to the Saguenay River in Quebec. One of the earliest Triscott paintings discovered to date, *Merrimac River Near Franklin Falls*, is in the traditional English academic style. The amount of detail in this

13- x18-inch painting of a New Hampshire scene is surprising. All the Triscott trademarks are there, including the finely detailed, luminous sky with its oncoming storm, the silvery sheen of the water in the winding river, the use of light and shadows, the dark greens of the foliage contrasting with the lighter green of the fields, and the minor role of the figures in the foreground.[11] *A Wood Boat,* painted in 1875, is another example of Triscott's early work, depicting a paddlewheel scow guided by a man with an oar. Its gray and white washes are characteristic of many of Triscott's later works.[12]

The earliest known exhibit of one of Triscott's paintings was recorded in 1874. *English Twilight* was shown at the Twelfth Massachusetts Charitable Mechanics Association Fine Arts Exhibition in Boston by its owner, Charles W. Slack, executive committeeman in charge of the art department of the association.[13] Another early mention of Triscott was in 1878 when he was chosen by the two appointed judges to be the third judge of awards for the Worcester County Charitable Mechanics Association Drawing School.[14]

In the late 1870s Boston was the center of the American art world, at least as far as aquarelists in Worcester were concerned. Bostonians have always been great collectors of watercolors for some occult reason, perhaps connected with thrift. When engineering began to wear upon him, Triscott moved to Boston to try to establish himself as an artist, although he continued to list himself as a civil engineer.[15] Within the year he was exhibiting at the Boston Art Club's annual exhibitions, and in December of 1881 he was chosen for the previously mentioned one-man showing with works such as *Near Woods Hole* and *On the Saguenay River between Ha Ha Bay and Chicoutimi.* Triscott's fluent washes of transparent color attracted much attention in the art world of Boston, this style being in marked contrast to the accepted norm. In fact, reviews spanning the next sixty-five years mention his unusual ability to achieve these fluent washes. He also received acclaim for his abil-

ity to blend and mix colors, another area where Triscott's style differed from that of other artists. A. J. Philpott, longtime art critic for the *Boston Globe*, wrote of Sears Gallagher, a pupil of Triscott's:

> There are few artists who have achieved such a perfect watercolor technique as this Boston artist. He can blend his colors in the mass with a skill so subtle you are not conscious of it. Artists like Winslow Homer, Triscott, Sargent, Benson, and Carroll Bill have done this sort of thing superbly well. In a sense it is a gift, on top of which there must be profound study and practice. It marks the difference between certainty and uncertainty in painting.[16]

In another article, Philpott refers to Triscott as the man who taught Winslow Homer, and a host of others, watercolor painting. That was when Triscott and Homer had studios in the same building in Boston. This agrees with the comments about Triscott having taught watercolor painting to America in his obituary in the *Boston Transcript*, but the remarks about Winslow Homer might be challenged by some in light of published works on Homer. However, evidence from a number of sources seems to support the claim that it was Triscott who taught Homer.[17]

The increasing popularity of watercolors in Boston in the early 1880s created a demand for teachers whose talents went beyond that required to instruct young women in how to paint floral displays. Many of the established artists of the day were taking up watercolor painting, and it seems likely that Triscott taught several of these. Although many artists never publicly acknowledged Triscott as their teacher, the fact that they took lessons has been determined by newspaper articles, exhibition records, and personal interviews. The artists uncovered from these sources include Homer, Sears Gallagher, William J. Bixbee, Grace Woodbridge Gee, Melbourne H. Hardwick, Charles Copeland, William Ladd Taylor, and Robert Henri.[18]

A comparison of William H. Downes's reference to the one man knowing how to do it in 1882, with the enormous growth in the number of those who could paint in watercolors in the ensuing decade reveals the amount of activity that was taking place in Boston during this period. This activity was noted in a review of Triscott's work at Chase's Gallery in December 1883, in which the *Daily Advertiser*'s critic began:

> There is great activity in the watercolor market and much more attention is devoted to that branch of the art than ever before in this city. The extraordinary and gratifying success of Mr. Homer's exhibition, just closed, and the rush of enthusiastic buyers to Chase's Gallery, eager to snap up a good example of Harvey, are phenomena which are rare enough to put on record in the local history of art, for unborn generations to marvel at. Following these wonderful events comes a special exhibition of S. P. R. Triscott's watercolors, at Chase's. Mr. Triscott has pursued this specialty for years past, but he has never made such a handsome showing as this. His thirty or forty landscapes, shore and marine views from Cape Breton, are all remarkably good, pure, and delicate in color effects, free and simple in handling, and unmistakably genuine impressions of natural scenes.[19]

This show came one year after Triscott's second major show, which was held in the Pelham Studio on Boylston Street. The Pelham show was reviewed by all the Boston papers, and the large watercolor, *A Wild Moor*, which had been shown with such success at the spring exhibition of the Boston Art Club, was the highlight of the show. The *Post*'s reviewer remarked that this painting had:

> attracted much attention by its breadth and strength of conception and delicacy of execution, and similar qualities are to be seen in this more recent work. The pure atmosphere of

nearly all his pictures is very noticeable, and many of his spring and summer studies show this to a remarkable degree. A flood of sunshine pervades a great many of his pictures, which are always so pure in tone and so tempered, even when strong in color, that they are soft and harmonious, and never garish … In the expression of distance in many pictures Mr. Triscott is very successful, and some of his strongest work is to be found in his depiction of far-off mountains, with their summits wreathed in light clouds and overarched by a clear, sunny sky.[20]

The *Globe* critic also praised *A Wild Moor* as he had done in the spring and alluded to it as "the largest picture in the collection, and in many respects the best…. It is a highly poetic conception, and the picture has also much technical excellence."[21] However, the reviewer disagreed with the *Post* critic when he noted that "the collection is very uneven, particularly in the coloring, some of the pieces being of great delicacy and refinement in this regard and quite skillful in their use of soft gray-greens, and others being exceedingly harsh and crude."[22]

The *Boston Evening Transcript* reviewer reported that Triscott's collection of paintings at the Pelham Studio "is attracting much attention."[23] Triscott was categorized as "one of the best of our local watercolorists," and several of his paintings were singled out for special notice, these being "*The Dying Year*, a lovely picture of autumn foliage, full of subtle beauty," and "*Looking up Long Pond*, a charming bit of Mt. Desert, with a wonderful effect of atmosphere."[24]

The Zepho Club was popular with the Boston art community in the early 1880s, and Triscott enjoyed the close friendships of many artists, including Willard Metcalf, W. L. Taylor, Charles Copeland, and C. H. Turner. Taylor and Triscott were probably

friends in the 1870s in Worcester, for Triscott is credited with teaching Taylor watercolor painting. A comparison of titles of pictures and dates shows that they visited many places together before Taylor married in 1888. One of their trips in 1883 was to Arichat, a small village on Madame Island off the southern coast of Cape Breton Island, which had been one of Triscott's favorite sketching grounds in past years. Triscott's *Cape Breton* was received with much acclaim by Boston's art critics, and *Arichat, C. B. '83* is an example of his work there.[25] This painting was first shown in 1883 at Chase's Gallery and again in 1886. A critic for the *Boston Herald*, probably Sylvester Baxter, describing the watercolors in the 1886 show, remarked:

> They are especially fresh in color and feeling and one is impressed, on entering the gallery, with their crisp and airy quality. They are impressionist in effect, but most of them are so in the best sense, and in nearly every instance there is some one pleasing feature.... It is in a picturistic arrangement of line, as in the quaint old wharf, with a mass of dark buildings and a boat against an intense blue sky, in Arichat, C. B.... The distinguishing quality of these pictures of Mr. Triscott's is, above all, their transparency. They have not depth of color, but rather clearness.[26]

Triscott's 1883 show marked the beginning of his becoming a regular exhibitor at the gallery of J. Eastman Chase, who at this time was showing the works of many of Boston's leading artists, including John La Farge, Winslow Homer, A. H. Bicknell, and J. W. Twatchman. This association was to last for many years, and as far as is known, was the only dealer Triscott used in Boston. It is not known how many paintings were sold at the first of these shows at Chase's, but judging by the reviews, Chase had made a good choice when he picked Triscott as his newest exhibitor. The *Transcript*'s review noted that "Triscott's coloring in these is re-

markably good, mellow, well blended, and characterful. He seems to work with a commendable instinct for eschewing the glaring effects that beset so many watercolorists, and when he introduces figures, they have some business where he puts them, and are not merely posing as landscape ornaments."[27]

Lyman Weeks, art critic for the *Boston Post*, stated that: "The present season has been prolific in unusually notable water-color exhibitions, but that of Mr. Triscott stands well with those that have preceded it."[28] Coming close on the heels of Winslow Homer's successful showing at Doll & Richards, these comments take on a special meaning. Continuing, Triscott's reviewer noted, "He was always original and vigorous, too much so, it has some-times seemed, considering the color medium with which he works—and these qualities are still pronounced in these pictures, tempered with a true feeling for nature. The compositions are ex-cellent, many of them being exceptionally well chosen from a pic-turesque point of view."[29]

The quest for success that brought Samuel Peter Rolt Triscott to Boston would appear to have been achieved, for he had quickly become one of Boston's leading watercolor painters. In the 1884 American Watercolor Society Exhibition in New York, Triscott showed four pictures. The largest of these, *Down in Maine,* ap-parently sold for $150, because it was never shown again, and in later American Watercolor Society exhibitions all his paintings were priced from $175 to $200. These works attracted the atten-tion of Downes, who said in reviewing Triscott's March 1885 show at Chase's:

> *The Bend of the River,* which was noted as a particularly original and genuine impression at the time it was exhibited in the show of the American Watercolor Society last month, is one of the best. It may be remarked in parentheses that Mr. Triscott had four pictures hung in good places in the

New York exhibition, and that they appeared to compare very favorably with any of the landscapes there.[30]

The catalogue for the 1885 show of Triscott's works at Chase's contains the first reference to the artist adopting his mother's family name of Rolt in his signature.[31] In interviews near his death, Frederick Childe Hassam was asked why he started using the name F. Childe in the early 1880s. Hassam recalled that this was at the advice of an older friend who noted that since young artists, particularly aquarellists, had little to call attention to themselves save their work, that he Hassam should capitalize on the good fortune of having such an unusual name and start signing his work that way. Hassam and Triscott were well acquainted, and Hassam's success in his November 1882 and February 1884 watercolor shows at Williams & Everett probably inspired Triscott to take advantage of his rather unusual given name. Not all works shown in the 1885 Chase showing were signed "Rolt," for one of the pictures, *Head of the Marsh*, is signed "S. P. R." and was painted during 1884.

The year 1884 also marked a style change from the early minutely and carefully done English style of a decade before and his thin water washes of the early '80s to the misty, poetic style of Corot and the Barbizon School which was to last spasmodically until the turn of the century. The *Herald*'s review of the 1885 show bears this out, for it noted his "vigorous and effective handling" of most of the works in the exhibit.[32] In contrast, "the pictures on the other side [of the gallery] are more in the artist's old, academic manner, and lack the freshness and spontaneity of the larger part of the collection."[33] This article reported that while Triscott was showing sixty-one of his works in the main gallery, "Mr. Chase was holding a second exhibition in one of his upper rooms of some watercolor drawings by John La Farge…. The collection numbers about a dozen and a half floral subjects, bits of

landscape and allegorical figures."[34] A number of the floral subjects were of the water lily, a favorite subject of La Farge.

The *Transcript*'s analysis, however, presented Triscott's varying style from a somewhat different viewpoint. Their critic, in his usual effusiveness, said, "Mr. Triscott has been like the French falconers, and flown at all he has seen for his subjects, and seems equally at home in all methods, which he apparently uses at will…. It is an excellent trait in a teacher of art, and we notice on the catalogue that Mr. Triscott proposes to take pupils into the fields with him again this year."[35]

The year 1885 also marked a number of other showings of work done the previous summer at Kennebunkport, Maine, and Mt. Monadnock, New Hampshire.[36] Triscott, along with three others, joined the chairman, Childe Hassam, as a member of the jury of the Boston Art Club's watercolor show. Although subjected to criticism from many fronts, jury duty at the Art Club's shows was considered an honor, and Triscott continued to serve in this capacity until the 1890s when he began his withdrawal to Monhegan Island. Triscott's successes at the American Watercolor Society's shows in New York no doubt prompted him to help organize the Boston Society of Water Color Painters. The first exhibition was held in December 1885 with thirteen members showing. Triscott's six works received mixed reviews, but his *Waiting for the Tide*, a marine with two groups of schooners lying motionless near the entrance to Kennebunkport Harbor, was described as having a "gray effect of exceedingly choice quality."[37]

The critics' analyses of Triscott's work became more varied and probing as the years went on. The *Transcript* devoted a long, detailed review to his show at Chase's Gallery in February of 1886, referring to it as "precisely what everyone has been waiting for, and which of late has been strangely deferred."[38] It went on to say:

For the last few years Mr. Triscott has been—outwardly, at

least—at pause and the advance he gave at first good promise of making has been absent. The exhibition last year was in the essential nature disappointing; sweet, delicate, lovely in color, pure in subject matter, but lacking the variety and individuality of Nature, and the sympathy and vital interest of the true painter. All the good qualities of last year are here, and more besides, very much more.... The several studies in pure greens are brilliantly good, with a life and sparkle and truth and individuality, the want of which has been lamented often. Mr. Triscott's choice of subjects is *invariably* to be commended, his poetic treatment and sweet feelings constant.... *After Sea-Weed* ... shows Mr. Triscott at his best, having all his qualities of sweetness and refinement, showing his power over clear, cool light and his sensitive choice of subject and masterly composition.... it holds place among the very best pictures of the year.[39]

The *Boston Globe* devoted its entire Fine Arts column to this show, and art critic Susan Hale, also impressed by *After Sea-Weed,* rambled on about the memories it brought back to her and apologized by saying, "This, perhaps is not *a propos de bottes*, but it is all called up by Mr. Triscott's picture. And this is the charm of them all, that they are suggestive."[40] After waxing eloquent for a half page, Miss Hale continued, "To return to Mr. Triscott, whom, after all, I do not mean to put at the head of all living artists, I think he has ... gained so much ease in handling his materials that he can turn his attention to special effects of light and atmosphere, and that having this skill he has the good fortune to be able to perceive rare moods of nature and express them on paper.... He has preserved his fresh perception of special subjects and has gained the power to produce them."[41]

Triscott's ability to suggest detail and yet retain simplicity was noted in the *Daily Advertiser*'s review of this show:

He suggests the details of vegetation with a degree of skill that deludes the vision, and on a close examination of certain of his foregrounds one is surprised to find how much has been given by summary methods and without niggling. Simplicity is indeed the prominent feature in much of his best work, but it is not carried to the extreme of emptiness. His skies are spacious, moving, luminous.[42]

Another of Triscott's characteristics was the use at times of large surfaces to paint on. Many reviewers commented on this, and invariably the comments were in the following vein:

The artist is still also inclined to choose large surfaces—larger than it seems to us is usually judicious, considering the limitations of the medium. But he achieves so large a degree of success with these large pictures that one, though not forsaking his own principles and opinions, is willing to confess that he does not often feel that the works are over-large. Mr. Triscott's style is broad and he revels in space, air, and color.[43]

Triscott's yearly trips to Kennebunkport, Maine, and later to Newburyport, Massachusetts, gave him ample opportunity to observe and paint the marshes which Martin Johnson Heade had made so famous. One point on which the critics seemed to be in unanimous agreement was that Triscott was a, if not *the*, master painter of marshes in America when it came to watercolor. The *Boston Evening Transcript*, in its review of Triscott's 1887 show at Chase's noted:

As a painter of marsh effects, Mr. Triscott stands almost first of all watercolorists; he seems to catch wonderfully well the rich and mellow coloring of the thick furry grass, contrasted with spaces of clear water, either deep and black in shadow, or pale in bright light.[44]

Likewise, the *Boston Herald*, reviewing a Triscott show at Chase's, stated:

> One of the best examples of his power of giving expression to the most delicate observations may be cited in *Sunset on the Marsh* where in the quietness of the scene, one is made to feel the gentle flush of the close of a summer day, and the tints of the twilight clouds are reflected on the level stretch of grass in an indeterminate shade just tinging the green. This picture is one of several beautiful marsh scenes in the neighborhood of Newbury.[45]

When the spring of 1888 arrived, six years had passed since Triscott's show at the Boston Art Club. During that period he fell into a regular pattern in his life and work. He had initially tried an occasional oil painting, exhibiting one each year at the Boston Art Club's oil shows in 1883, '84, and '85; but these did not impress the critics, for no mention of them is ever made in the reviews. Each February he would exhibit at the American Watercolor Society in New York, and this was usually followed by his one-man show at Chase's, and then jury duty at the Boston Art Club, where he always exhibited. He would then leave Boston for Maine, usually staying there until the first snowfall of winter. From titles of pictures and notes in the Boston papers, it can be established that he spent his summers along the Maine coast, usually at Kennebunkport, and in the fall he would sometimes go to Mt. Monadnock, New Hampshire, returning to Boston to resume teaching watercoloring and to work on new pictures for the following season.

The spring of 1888 marked a break in this pattern, however, for Triscott and W. L. Taylor embarked on a trip to England which would keep them there until fall. Perhaps the severity of the winter just ended—which brought storms so harsh that the term *blizzard* came into widespread use—had influenced Triscott to seek refuge in the Devon countryside he had known as a boy, for there

he would be unlikely to encounter storms dropping fifty inches of snow in four days. The blizzard in Boston from March 11 through 14 had done just this, and its snows spread chaos and death, choking roads, burying trains, severing communications, and even stopping the mail. To Triscott, Robert Browning's "Oh, to be in England/ Now that April's there," would have seemed like magic words after such a winter.

Just as Homer's trips to England seemed to give his work increased vitality, this same effect was noted in Triscott's work once he arrived there. He and Taylor tramped all over the moorland district of Dartmoor, which he had known from many years before, painting as they went. The villages of Chagford, Moreton Hampstead, and Wallabrook were all painted, not once, but many times. Triscott, who up to now had been known for his mountains, shore scenes, and marshes, portrayed rural England with its thatched-roof cottages, lovely gardens, simple farmyard scenes, and ever-changing atmosphere. *English Cottage* at the Boston Museum of Fine Arts depicts a cottage with its thatched roof and expansive garden. Although not as vibrant as many of his English scenes, this painting faithfully portrays the typical Devon cottage of the day. Exmoor, the land of Lorna Doone, scene of Blackmore's great novel, figured heavily in many of these works. A trip to Porlock produced a small painting *June, Porlock*, which represented the valley supposed to have been the scene of the robber Doone's exploits. Triscott did many scenes of Porlock and nearby Porlock Weir, small seaside hamlets, nestled under the side of the hills. *In the Churchyard, Porlock* shows English vernacular architecture and emphasizes the proximity of the hills. The grasses in this painting are especially green, and as the *Boston Post* remarked, "… it is a positive pleasure to look at it."[46] A few miles to the east on the road to Minehead is Allerford, with its famous pack-horse bridge, huddled at the foot of steep, wooded hills. It was here that Triscott

did one of his major works, *Allerford Bridge*, which was shown at the Art Institute of Chicago in the spring watercolor exhibition of 1889 and later at the Twenty-Third American Watercolor Society Exhibition in 1890.

Triscott's first showing of his English works was in early December 1888 in the Boston Society of Water Color Painters Exhibition, where he displayed *A Bit of Dartmoor* and *The Last Gleam*. The *Boston Daily Advertiser*'s review of the show referred to Triscott's painting of "sheep-dotted Dartmoor" as one of two paintings that "are among the very finest in the exhibition."[47] April 5, 1889, was the opening date for Triscott's show at Chase's, and the following day the critics began a stream of enthusiastic reviews. The *Boston Evening Transcript* observed that: "The superiority of the drawings made in England over Mr. Triscott's previous works is incontestable. They have a freshness and purity of color, completeness, and breadth which are highly commendable."[48] By April 17 the *Boston Post* reported that: "Mr. Triscott's watercolors at Chase's Gallery are creating a genuine sensation. His *Coming Shower, Devon* is a masterly treatment of a theme extremely difficult for the watercolorist to handle. The mountain, half obscured by the rain, the heavy clouds ready to discharge their burden, the tumbling river, and moss-covered rocks made a forcible and telling picture."[49]

This show would mark the final exhibition of the 1880s for Samuel Triscott, and it seems fitting that it should end on such a high note, for the decade that had started in obscurity had been one of much fulfillment and personal acclaim for the artist. The most important advance from Triscott's standpoint was his proven ability to support himself from his painting, thus freeing himself from civil engineering as a vocation.

The decade of the 1890s marked the beginning of a period in which Triscott made many changes in his lifestyle and values. His

association with Chase's Gallery, which had reached a high point in the 1889 showing of his English scenes, now faltered. Although in 1890 Triscott became a charter member and exhibitor at the New York Water Color Club, and exhibited at the Boston Art Club, the Boston Society of Water Color Painters, and the American Watercolor Society in New York, no evidence is found of any one-man show at Chase's that year.

The following year Triscott exhibited six of his works at the Art Institute of Chicago, receiving a favorable review in the *Chicago Tribune*, which noted that he "has also touched on the melancholy of nature. The desolate feeling in *A Moorland Road,* with its broken lines of water, is exquisitely suggested."[50] While this show was still in progress, Triscott sent three watercolors to the Boston Art Club's Forty-Fourth Exhibition, where he received top billing from a newspaper critic:

> It is difficult to particularize, where so many drawings claim mention for excellence, and I do not intend to do so. But in landscape, Triscott's *Willow Road* and Hardwick's *Sunny Morning* will not be passed by.[51]

For the second year in a row, Triscott did not have a one-man show at Chase's, instead exhibiting fifty watercolors at the Art Students Club in Worcester. A number of the works depicted scenes around Cutler, Maine, then as now a remote part of the coast where Triscott must have spent the summer of 1890. He also showed more English scenes from his 1888 trip, including *Old Garden, Mortonhampsted,* a scene similar to *Cottage Garden, Mortonhampsted, Devon* and *English Cottage,* the latter held by the Boston Museum of Fine Arts. This season's shows also included three works at the American Watercolor Society in New York, three works at the Art Students Club's Eleventh Annual Exhibition in Worcester, and four works at the Art Students Club's Eleventh Semi-Annual Exhibition.

With the coming of spring and the end of the show season, Triscott would appear to have deferred a trip to Maine, for at least part of the summer, preferring to work in the area around Newbury, Massachusetts, and probably going to the New Hampshire mountains in the fall. It would also appear that he had settled any differences with Chase, for the following spring, in addition to his usual showings, Triscott had another one-man show at the gallery on Hamilton Place. The review in the *Boston Herald* on March 24, 1892, stated that: "This collection shows the artist at his very best—and that, it hardly need be said, is extremely good." The reviewer praised *Sunset on the Marsh* as "one of several beautiful marsh scenes in the neighborhood of Newbury." In a somewhat different vein, the reviewer discussed the feature painting of the exhibition, *The Old Homestead,* which was described as "a very felicitous picture, filled with many details most difficult to harmonize, deserves special attention as a presentation of one of the most attractive aspects of rural New England, yet extremely difficult to handle picturesquely." This must have been a large work, for it had been shown the previous month at the American Watercolor Society in New York, where it was priced at $300. This painting was also discussed in the *Transcript*'s review of the exhibition at Chase's, but this review could not be considered complimentary:

> The thirty watercolors…have an almost reactionary aspect of old school conservatism to eyes accustomed to the high-pitched and violent effects of modern landscape painting. It is as if the artist consciously turned away from the ultra-gaudy fashion of the day and the abuse of broad methods, to go back to a style even more antiquated and finical than is natural to him. *The Old Homestead* is a composition which looks and is hopelessly literal and painfully conscientious. It is over-full of details which have no interest, and its lighting is pallid and cold. It is executed with a dry touch

which seems intentional, which is far from being Mr. Triscott's habitual manner of working. The hills in the distance are well painted, but there is no interest in the foreground, no center of interest anywhere, and the absence of well-contrasted lights and shadows makes the scene tame and flat.[52]

Three days after the show at Chase's closed, the Boston Art Club opened its forty-sixth annual show of watercolors, where Triscott exhibited three works. This is the exhibition where Downes, writing in the *Boston Evening Transcript* noted: "The watercolorists who should shine the brightest in a crowd (such as Childe Hassam, George Smillie, Francis Murphy, S. P. R. Triscott) are easily outstripped by many less-known competitors."[53] What effect these reviews had on Triscott is only open to speculation; but in light of what was to happen in the next few years, one must wonder if perhaps these first generally negative opinions might have helped to contribute to his gradual withdrawal from the Boston art scene.

The year 1892 was also the year in which Triscott first discovered Monhegan Island on the coast of Maine. At that time it was not the art colony that it was destined to become. True, a few artists, such as Milton J. Burns, illustrator for *Harper's Magazine*, George Wharton Edwards, and W. E. Norton had visited the island over a ten-year period, but for the most part it was a busy fishing community of ninety hardy and independent souls. William Claus, an illustrator for the *Boston Globe*, had visited Monhegan about 1890, and he became a one-man ambassador of good will for the sea-girt island.[54] Newspaper Row, as that section of Washington Street in Boston was known, was only a stone's throw from the Century Building, where Triscott and Sears Gallagher, a pupil of Triscott's, had studios. During each day, reporters, artists, lawyers, and others met to socialize and exchange ideas, and at these meetings Claus expounded the virtues of Monhegan. Legend has it that Triscott and Gallagher's first trip to the island was planned in this

fashion during the winter of 1891–92. Gallagher remembered the year well: "I came here to sketch over forty years ago. It was the year Jim Corbett knocked out John L. Sullivan. Some friends brought me here."[55] Triscott showed a large watercolor entitled *Manana—Sunrise* at the American Watercolor Society in late January of 1893, and this first showing of a Monhegan scene establishes his arrival there in 1892. Triscott and his friends boarded at the Albee House, owned by Sarah Elizabeth Albee.[56]

A. J. Philpott, writing about Monhegan, Sears Gallagher and Triscott, observed:

> For it seems to have the power—as the Irish say about some beauty spots in Ireland—of "casting a spell over you." You either like Monhegan or you don't like it. But if it "casts its spell" over you—then you are its lover for life…. To get back to the power of "casting spells" which Monhegan is reputed to have. It is not altogether a fancy, especially when you consider what it did to S. P. Rolls [*sic*] Triscott—the man who taught Winslow Homer and a host of others, watercolor painting.
>
> Triscott visited the island one summer about fifty years ago, and was so fascinated with the elemental beauty of the place, that he came the next year, purchased one of the fishermen's cottages, fitted it up with a studio that resembled the cabin of a vessel—with portholes, etc. Then he packed a little organ which he used to play; also a guitar and some household utensils, including a supply of paper and watercolors, and settled down in the place—and remained there the rest of his life—twenty-five years—during which time he never set foot off the island.
>
> He had fallen under the spell of Monhegan.[57]

Philpott's remark about Triscott never setting foot off the island is apparently not correct in the literal sense, for the artist did

return to Boston for a few months each winter in the years 1893–95 and 1899–02; and he was known to have gone to the mainland for eyeglasses, but this would appear to be the extent of his trips off the island.

The reason for Triscott's sudden change to an almost hermit-like existence on this remote island is covered in Philpott's tribute upon his death. Philpott recalled these events:

> What was it that drove the popular Boston painter of fifty years ago, and forty years ago … to become a recluse on the island of Monhegan… ? There was, naturally, a rumor on the island—it took various fantastic forms—that "Trissy" had had a love affair—some society woman who died—and that he sought the solitude of Monhegan to assuage his grief.
>
> The writer asked "Trissy's" friend about this rumor, but the friend shook his head and said he did not believe it. He said he wasn't sure of course, as "Trissy" was reserved in many things, but he doubted it. "As I see it," said the friend, "Triscott had been living in his city studio in which there was only a northern skylight, that when he first went to Monhegan … and he saw sky all about him, and the sea he loved and the ledges, he just fell in love with the place…. He was sick of the city and city life."[58]

As with many rumors, this one had its basis in fact, for shortly after his article appeared, Philpott had a visitor, and her story confirmed the rumor. This information was published later by Philpott in the following 1944 article, "Romances of 2 Artists Have Proved Intriguing:"

> Few—if any—of his friends suspected that when S. P. Rolt Triscott established himself in a fisherman's cottage on Monhegan … that it was due to a love affair which went awry. He became a recluse…. Sears Gallagher and the late William Claus … were about his closest friends.

But they knew nothing of the romance with a girl cashier in the Parker House, which caused Triscott to become a recluse....

I intimated, in the obit I wrote, that possibly there had been a romance in his life.

A few days later the Romance called on me in the office and brought along a sketchbookful of pencil sketches that Triscott had given her as a token of his love and esteem.

She was a nice little old lady.... At the time she was cashier at the Parker House, where Triscott dined, and he made love to her. So did another young man who worked ... on Summer Street.

Triscott kept it a sealed secret all his life.[59]

Although this move to Monhegan had a profound effect on Triscott's personal life, turning him gradually into an almost hermit-like recluse, it did not adversely affect his art, for he continued his prolific production of watercolors.

The year in which Triscott purchased his house on Monhegan marked an event which had a negative effect on the sale of art in America, the Panic of 1893.[60] Sales at the New York Water Color Club's November exhibition were down from the preceding years, but with those pictures that found favor with the buying patrons, Triscott's *The Coming Storm* brought one of the highest prices of any picture sold—$250. This was one of the paintings reviewed by the *New York Daily Tribune*. The reviewer had mentioned one of Triscott's landscapes, but stated that the only landscape that deserved special attention was one of John La Farge's South Pacific Society Island scenes. The writer then continued, "There are several sea pieces in the exhibition which deserve association with Mr. La Farge's study by virtue of their able treatment of ocean color," and one of those was "Mr. Triscott's large coast scene."[61]

The same year Triscott also exhibited *A Salt Marsh* and *Coast*

of Maine in the Sixty-Second Annual Exhibition of the Pennsylvania Academy of Fine Arts, marking the beginning of an association with that august institution.

However, Triscott's association with Chase's Gallery was about to end. Triscott mounted his last one-man exhibition there in April of 1894, and reviews in the Boston papers reverted to their former praise. Beginning with Triscott's first one-man show in Boston, reviews of his work almost invariably occupied the lead position in the reviewer's column, indicating that his paintings were usually the most newsworthy in the eyes of the critics. This 1894 review in the *Boston Evening Transcript* was no exception, ending:

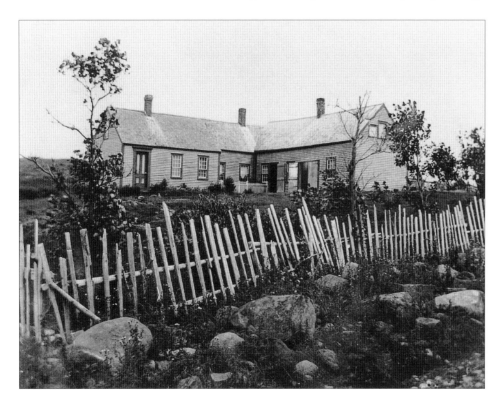

S. P. Rolt Triscott's house on Monhegan Island prior to the construction of his stone chimney, porch, and dormer window.
Courtesy of the Monhegan Museum

the merit of [the works] consists in their individual stamp and singleness of aim, and in this respect all the work of this artist is worthy of approval and esteem. Mr. Triscott evidently consults no guides in his painting but his own perceptions of nature, and it is this independent and self-reliant attitude which gives his pictures a place apart.[62]

The *Boston Herald*'s reviewer perceptively remarked:

A notable aspect of the exhibition is its impression of the effect that the prevailing newer school can make upon the methods of an intelligent conservative. For the collection very plainly represents two distinct tendencies, as if the pictures were painted at two different periods of the artist's activity. In one class the dark gray, and even blackish, tones of the standard English school prevail.... But in his work of more recent origin Mr. Triscott gives distinct evidence of the power of the later influences that work for purer tones, greater clearness, and more pervasive light....[63]

It was during the period of his show at Chase's that Triscott was naturalized in Boston on April 28, 1894. When he was sworn in as an American citizen, the witness to his oath was Sears Gallagher.[64] Upon returning to Monhegan, Triscott began making additions to his home, adding a studio on the north end of the house with a large, English-style chimney. He also planted flower beds and a vegetable garden. Philpott recalled the gardens as seen by one of Triscott's friends:

Oh, yes, there was a garden. That was almost as important as the house for Triscott loved flowers as he did cats, and he raised a beautiful garden of flowers each year, and he delighted to give some of these flowers to people on the island and to visitors. And he loved to talk about these flowers—especially his dahlias and begonias. And he loved to raise vegetables. He was a splendid cook, and he delighted to

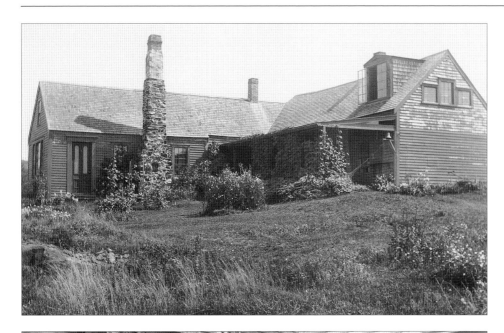

TRISCOTT'S HOUSE with his addition of the stone chimney, porch, and dormer window.
COURTESY OF THE MAINE HISTORIC PRESERVATION COMMISSION

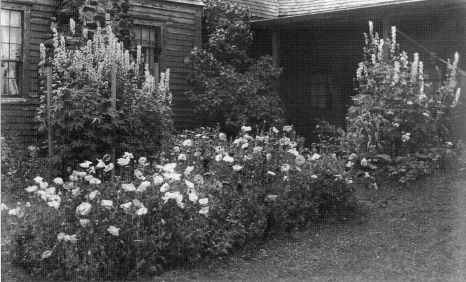

TRISCOTT'S GARDEN.
COURTESY OF THE MAINE HISTORIC PRESERVATION COMMISSION

prepare salads and such things for visitors. He raised wonderful lettuce. He knew how to cook fish and lobster. He made a wonderful lobster salad.[65]

The house with chimney, studio, and flower garden is seen in a Triscott watercolor of his home. This painting was no doubt executed after the turn of the century, for by then Triscott was doing more of his work in the tight and minute English style. But much of his early work on Monhegan reflected the direct, free, poetic approach of the Barbizon School. Although Triscott no longer exhibited at Chase's, he continued to show in Boston at the Art Club's watercolor exhibition and the Boston Society of Water Color Painters, of which he had become vice president. In 1896 the Boston Art Club offered large cash prizes for paintings in their annual

TRISCOTT'S PARLOR.
COURTESY OF THE MAINE HISTORIC PRESERVATION COMMISSION

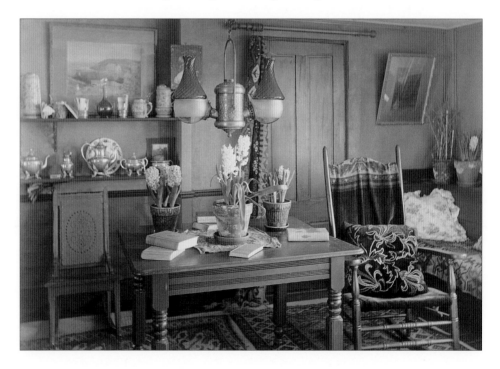

winter oil exhibition. Triscott had not exhibited an oil painting for a decade, but the lure of the $2,500 first prize apparently persuaded him to enter *The Ledge* in the competition. The judges were not impressed, nor were the art critics for the Boston papers, but it is interesting to compare his oil treatment of Christmas Cove on Monhegan with his watercolors. The same year he exhibited two watercolors at the Jordan Gallery, part of the Jordan Marsh Company, one of which—*The Breakers*—was illustrated in the catalogue. He also continued exhibiting at the Art Institute of Chicago and, like Winslow Homer, held a one-man show "of aquarelles" at the O'Brien Galleries in that city, featuring "Views of Maine."[66] This association with O'Brien was apparently successful, for Triscott in an 1898 letter to William Macbeth, the New

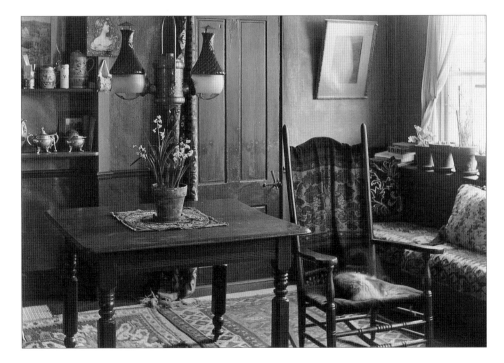

York dealer, wrote, "I enclose a price list which is nett [*sic*], the same as I give Mr. O'Brien who has sold a great many for me the last few years."[67]

Another new association in 1896 was with the Poland Spring Art Gallery at South Poland, Maine. The state of Maine had constructed a large, ornate building for the World's Columbian Exposition held in Chicago in 1892–93, and at the completion of the fair, it was scheduled to be demolished. Hiram Ricker, who had made the spa at Poland Spring a rendezvous for the world's well-to-do, decided to make a bold move. He had the building dismantled, each piece was marked as to location, and the entire structure shipped to Maine and reconstructed on the grounds of the Poland Spring Hotel, where it stands to this day. He then used the

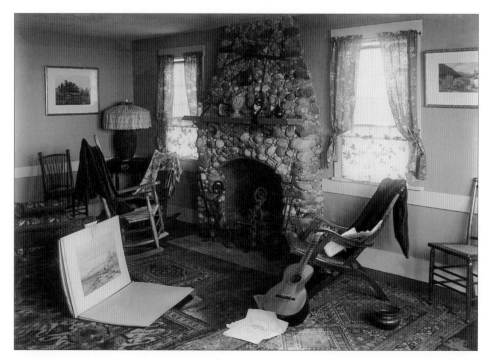

TRISCOTT'S STUDIO, showing his stone fireplace.

building to house art exhibits, with the list of exhibitors over the years a veritable *Who's Who in American Art*. All the paintings were for sale, and Triscott sent five pictures in 1896. His *Manana Island—Monhegan: Sunrise* had a title similar to the *Manana— Sunrise* shown at the American Watercolor Society's 1893 show in New York and is quite possibly the same painting.

If Samuel Triscott had come to Monhegan to assuage his grief, he was not doing it by brooding inactivity; he made his own frames, did his own house repairs, and took up a new avocation, photography. In addition to these activities, the artist surveyed a large plot of land on Monhegan that he and an islander, Frank Pierce, later developed. It would appear that Triscott had completely supported himself with art earnings since 1880, never having to sup-

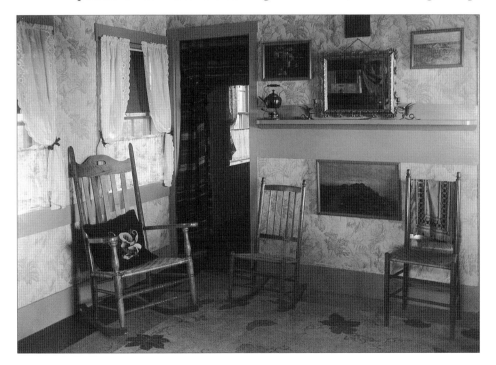

A CORNER of Triscott's kitchen.
COURTESY OF THE MAINE HISTORIC PRESERVATION COMMISSION

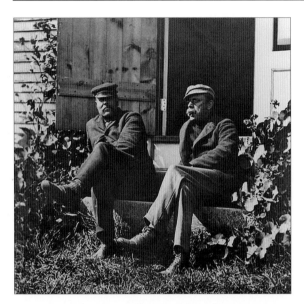

plement his income with surveying. Local people on Monhegan believe that Triscott undertook this surveying only to acquire half title to the large tract of land that Pierce owned. Triscott and his partner were apparently looking to the future, for twelve years later they started to sell lots for summer cottages and continued to do so until Triscott's death when the remaining land was willed to his housekeeper.[68] Triscott's association with Pierce was fortuitous, for Pierce had the ability to make profitable everything he touched. The following year, Triscott and Fred McClure, a former surveying partner of Triscott's and city engineer of Worcester, bought a fish house and five-eighths interest in a flaking yard on Monhegan.[69] A corner of this building may be seen in the right side of Triscott's *Manana Island—Monhegan: Sunrise*. Although the deed lists McClure as part owner of the structure, it was commonly referred to as the "Triscott-Pierce fish house." Pierce was also the developer of the Island Inn, starting with what was known as the Pink House and enlarging it into the impressive structure that it is today.

With the passing of summer and fall in 1896, Triscott elected to stay on Monhegan during the cold Maine winter, forsaking a return to the city. He remained on the island the following two winters, painting many pictures directly from nature. Triscott describes this in an 1898 letter to Macbeth:

> I have spent the last two winters on this island and have painted out of doors every month of the year, and, as you may not know the location of this place, will mention that it is ten miles out at sea from the nearest point of the Coast of Maine so that I have a good chance to paint surf and shore such as cannot be got on the mainland....[70]

Triscott sent four pictures to Macbeth, one of which was *The Pathless Woods*, a picture of a pool in Cathedral Woods on Monhegan. The title no doubt was derived from Byron's *Childe Harold's Pilgrimage*, Canto IV:

There is a pleasure in the pathless woods,
There is a rapture on the lonely shore,
There is society, where none intrudes,
By the deep Sea, and music in its roar:
I love not Man the less, but Nature more, …[71]

During these winters on Monhegan, Triscott produced many fine snow scenes, a challenging subject for watercolorists to portray accurately. One of these pictures which shows that Triscott experimented with many styles is *A Bright Day Monhegan*, done in the fashionable Japanese style. This picture, with its windblown gnarled trees, snow-covered hills, and ever-present crows, represents Triscott at his best.

The critics in Boston were enthusiastic in their reviews of these light, airy new pictures. At the Tenth Boston Society of Water Color Painters Exhibition, in the spring of 1898, Triscott showed six scenes which received the following comments:

> Mr. Triscott has blossomed out in great style this year with marines and winter landscapes and autumn marsh effects which are far beyond anything he has ever shown. His largest picture, a marine piece, is splendid for its resonant color, purity of tone, transparency of atmosphere, and vigorous drawing of wave movement. The snowy landscape hung underneath the marine is also beautiful.[72]

Triscott's works were also shown at the American Watercolor Society Exhibition in New York that spring, and one of his pictures was *Edge of the Woods*, a painting in the artist's more traditional English style.

The Boston Art Club, in its fifty-eighth annual exhibition, honored Triscott as it never had before by buying his unusually large watercolor *A Squall Coming*. This 36- by 60-inch picture was the main subject of the *Boston Evening Transcript*'s review of the show:

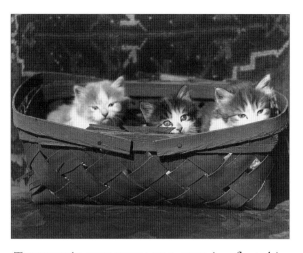

TRISCOTT'S AFFECTION FOR CATS is reflected in his photograph of three kittens in a basket.
COURTESY OF THE MAINE HISTORIC PRESERVATION COMMISSION

33

In S. P. R. Triscott's large and gloomy marine composition, entitled *A Squall Coming* (88), we admire the truthful descriptive detail, the patient and faithful representation of all the component parts of an impressive and portentous effect, but we miss the suggestiveness, the hint of human tragedy, the ship element, that belongs by right in the complete sea picture, and without which there is a certain emptiness, as it were, of the stage and its scenery without the actors. Mr. Triscott is undeniably melancholy in this large picture. His other picture, in the next room, *The Seal Ledge—A Northeaster* (313), is fully as spirited, is replete with breezy movement, and is not so depressing. The drawing in both works is admirable.[73]

After this most successful season of shows, which included paintings shown at the Pennsylvania Academy of the Fine Arts, Poland Spring, and the Worcester Art Museum, Triscott returned to Boston for the winter, where he exhibited at the Art Club and the Society of Water Color Painters, as well as the American Watercolor Society in New York. This time he chose to show a large painting, 19- by 36-inch, *A Sunken Ledge*. Although this painting was not sold, it remained one of Triscott's favorites, for it hung in his studio until his death and for many years afterwards. This is a painting of utmost simplicity of subject, with only the sunken ledge, a large wave breaking over it, and the gulls waiting to devour any bit of food. The sheer lack of any distracting detail in the hazy distance makes it a powerful picture. Triscott also showed *Winter Morning*, which was incorrectly titled *Early Winter* in the review of the December 1899 one-man show at O'Brien's. This show at O'Brien's also displayed other winter scenes, and the *Chicago Times Herald* reviewer described one of them:

> Another truthful scene is one in which there is expressed the feeling of boundless solitude. The hour is just before sunset.

A stretch of snow mantled earth streaked with broad purple and blue shadows shows footprints. A single house acts as sentinel and the distant hills stand out from a cheerless sky…. There is healthful simplicity in all of Mr. Triscott's performances. His honesty is convincing, one feels that he derived his inspirations directly from nature.[74]

This exhilarating review of Triscott's final showing of the century was the one that began, "S. P. R. Triscott is pronounced by many critics the most able aquarelist in America."[75] Another critic who held Triscott in high esteem was Sadakichi Hartmann. He wrote in his *History of American Art* in 1901:

The work of comparatively few water-colorists is characterized by any individuality or strength. If we mention the names of S. P. R. Triscott, Sears Gallagher, and Ross Turner, all three New England artists, C. C. Curran, Albert Herter, A. E. Sterner, W. L. Lathrop, Clara McChesney, and Rhoda Holmes Nichols, who has often proved herself a master in this medium, we have all but exhausted the subject.[76]

In spite of all this acclaim, evidence points to the fact that it did little to stem Triscott's growing reclusiveness. His first decade on Monhegan was a period in which he gradually began to withdraw from his association with the general public. He of course had his Boston friends of many years' standing, William Claus and Sears Gallagher, and he made friends with the year-round fishermen and their families, especially the children, many of whom he seemed to dote on, making them presents of his small watercolors from time to time. He also would attend parties on the island given by another old friend, Boston Judge Charles Jenney. Jenney was widely known in ornithological circles, and during one of these observation trips, he met Triscott painting from nature on a North Shore beach. Jenney's office was near Newspaper Row in Boston, and there he joined in the comradery of those journalists, artists,

lawyers, and others who met each day for talk and drink. During these talks he, too, was prevailed upon to find out firsthand about Monhegan Island. After only a few days there, he sent word back to his family in Hyde Park, imploring them to come at once for he had found the most perfect spot on the face of the earth.

Jenney became a good customer of Triscott, buying several paintings for his residence in Hyde Park and later for his new summer home on Monhegan. Jenney and his brother Edwin had decided to build twin cottages on the island in a choice location just north of the public wharf. They brought the building materials and carpenters from Boston and were assisted by a young artist-cum-carpenter who had just recently made Monhegan his home—Rockwell Kent. Kent detailed this project in his autobiography, *It's Me, O Lord.*[77]

Triscott also had a few friends from his Boston days such as Winslow Homer, who called on him occasionally, and Fred

FROM LEFT TO RIGHT: Unidentified woman, S. P. Rolt Triscott, and Frank Myrick viewing the Monhegan headlands.
COURTESY OF THE MONHEGAN MUSEUM

McClure of Worcester, Massachusetts, who spent a summer vacation on Monhegan. It is reported that, "He [Triscott] at least put the island of Monhegan (a Maine coastal island) on the map, for one of his summers he took Mr. McClure (later a member of the Art Students Club) with him for his summer holiday and we saw these sketches occasionally at our Art Students exhibitions."[78]

Eric Hudson, George Wharton Edwards, Frank Myrick, and George Clowes Everett were artists who also befriended Triscott in these early days, which are remembered in the following 1914 newspaper account:

> Judge Jenney, like George Clowes Everett, the artist, and George Wharton Edwards, artist and author, and S. P. Rolt Triscott, artist, has seen Monhegan grow out of the sea mists of the horizon-line of Maine summer resorts into the full blaze of its present prosperity. A score of years ago these

FROM LEFT TO RIGHT: Frank Myrick, unidentified woman, S. P. Rolt Triscott.
COURTESY OF THE MONHEGAN MUSEUM

FROM LEFT TO RIGHT: Frank Myrick,
unidentified boy, S. P. Rolt Triscott.
COURTESY OF THE MONHEGAN MUSEUM

men were all housed in the modest homes of the native fishermen. Today each has his own handsome cottage, although Edwards no longer returns, perhaps under pressure of business interests outside, perhaps because of the low barometer of island sentiment towards him for the publication of island secrets in his *Thumbnail Sketches* and *Petit Matinic*.[79]

Eric Hudson's daughters, Julie and Jackie, remembered their parents telling them of their father, Triscott, Everett, and Gallagher having "toast and tea" each afternoon on the porch of the Albee House. Triscott reportedly asked Mrs. Albee once when she was serving them why she did not change the limited menu occasionally and have "tea and toast" instead of always "toast and tea."

These early artists on Monhegan presented a stark contrast to the local fishermen. Most of them, save Rockwell Kent, dressed in a manner befitting gentlemen of the day, and the ritual of afternoon tea was common among the group. Triscott was described in one of Philpott's articles as follows:

There was nothing unkempt about him. He always dressed neatly, and until within a few years he wore white flannel trousers in summer and white shirts. He always wore a cap. He never raised a beard. He wore a mustache. He lived well and enjoyed himself. He was a cultured man, and he had a fine library. He read a great deal. He liked music, and he played the guitar. He loved poetry, and he wrote some pretty good verse. He occasionally would send me one of his poems. And I treasure them. He had a wonderful memory and a great fund of stories. Some of them were a little risqué—of the raconteur type. He was a robust, natural kind of man—tall, rather thin and wiry. I never knew him to be sick. He enjoyed wonderful health. Of late years his legs troubled him a little, but he never complained.[80]

Dr. John Cabot of New York was another summer visitor

who shared a friendship with Triscott. Dr. Cabot built a cottage near Triscott's home, and it would appear that their mutual love of music brought them together. Lelia Richards Libby wrote, "The guitar … was a relaxing companion for Triscott in his few leisure hours. The late Dr. John Cabot, a close neighbor, chose the flute as his musical instrument, and together, the two friends enjoyed many hours agreeably in duets."[81]

While these accounts portray Triscott's life during his first decade on this island, later reports and interviews confirm that he did become withdrawn, first from "summer people" and later from many of the natives. In 1914 it was reported that:

> Triscott, the Englishman, now in his sixties, has made this his permanent home where he paints all winter, and in some respects hibernates in summer, since his English antipathy against crowds, even of Monhegan size—drives him back,

S. P. ROLT TRISCOTT with Frank Myrick on the wheelbarrow.
COURTESY OF THE MONHEGAN MUSEUM

39

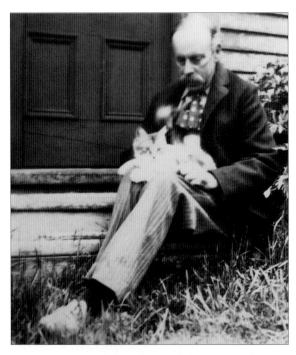

S. P. Rolt Triscott with his cat Spider, summer of 1919.

as a zero temperature drives bruin, into his little red cot on the hill, here to seclude himself until the village post office once more, in the cold blasts of fall, gathers together at mailtime only the fisher-folk of the isle and the few of the year-round artists.[82]

Raymond Chadwick brought the first motor vehicle, a Ford truck, onto the island about 1920. Triscott had never seen such a contraption, and there was great speculation as to whether this attraction would bring him out of the house. After it was driven to his house, he did come out and examine it. This appearance was so unusual that people remembered the occasion for years after. By 1923 Triscott's trips out of the house were still occasions to be remembered. Lelia Richards Libby recalled:

People said he was a famous artist, and sometimes talked over my head in a puzzling way, and one phrase, "disappointed in love" stuck in my young mind for years afterward.

I gathered that because of this fact, "Triscott" as he was called had chosen to give up his busy life in the large city to spend the rest of his days on Monhegan Island. He used to go away on trips, business trips, I had heard, but now he rarely left his own yard.

I heard that islanders thought nothing of this until one evening when the men gathered at the village store.

"Yep, he went down to the shore this morning—couldn't hardly believe my eyes, …" a fisherman spoke up.

And the news that Triscott had walked in the village that day traveled like the wind from house to house.[83]

Many islanders remembered Triscott as a "people hater." Alden Stanley, who as a boy had the job of delivering the Sunday paper, recounted that Triscott would put his foot in the door, allowing an opening only wide enough to pass the paper, and then shut the door, returning several moments later with the payment. How-

ever, there were those islanders whom Triscott would bring into his house and give small favors. As a child, Manville Davis had the job of supplying Triscott with fish to feed his cats. Triscott was extremely fond of cats, and many felt that he made a fetish of them. He often photographed them. Manville was welcome in Triscott's house and spent hours listening to stories of his youth in England. The artist said that Monhegan's rugged coast reminded him of Southwest England, of sitting in his house as a boy looking out over the English harbor, and of how much he loved the sea. Triscott gave Davis his *National Geographic* magazines and introduced him to newspapers and the "funnies." Manville and his sister Josephine Townsend told of Triscott giving them such delicacies as the English biscuits he had specially shipped from S. S. Pierce in Boston.

Dorothy Wincapaw Robinson remembered that each night she and a girlfriend brought Triscott two cigars and a can of salmon to feed his cats, and she recalled him "as someone who didn't like people at all."[84] In contrast, Lelia Richards Libby wrote that each night, after she finished her errands for him, Triscott would give her a bowl containing "a layer of cranberry sauce with broken Mary Janes on top, and over all, lots of rich canned milk. 'Bungabalorous Pudding' was Mr. Triscott's comic name for the bizarre, rich concoction—an absolute duplication of his own dessert each night."[85] Other interviews present an equally checkered view of his personality. Thus, it would seem that Triscott made many friends during his first ten to fifteen years on the island. After that time, he was more inclined to stay at home, picking his friends carefully, even among the children of the island.

Ironically, Samuel Triscott, who had come to Monhegan perhaps because of disappointed love, was to find that his closest, most valued associate on the island was to be a young island girl, Nellie Humphrey. This association was strictly a business arrangement and a platonic friendship in which no romance was ever hinted.

S. P. Rolt Triscott, late in life, holding one of his cats.
Courtesy of the Maine Historic Preservation Commission

41

S. P. ROLT TRISCOTT at his garden gate with a
young admirer, 1910.

COURTESY OF THE MONHEGAN MUSEUM

Nellie, the daughter of William Humphrey, captain of the EFFORT, the island's mail, freight, and passenger boat, became Triscott's housekeeper. Nellie did all of his cleaning and laundry, and prepared most of his meals until she married Hiram Colomy in 1921. Afterward, she stopped cooking for Triscott but continued her other duties. Monhegan's oldest residents could remember Triscott rowing Nellie around the harbor in his small boat or drifting while he played his guitar. Triscott was apparently highly appreciative of Nellie's assistance, for he left his entire estate to her.

When Triscott exhibited at the Boston Society of Water Color Painters in the spring of 1902, he showed a large number of works, among them *Lobster Cove—Monhegan*. Viewing the show, Downes made the following note on his program: "Tendency towards English styles and methods in the work of Triscott...."[86] Triscott was very productive on Monhegan, and many of these pictures show to some degree a return to his tight, academic English style of the 1870s. He apparently began to paint in whatever style pleased him and did not worry about what the critics would say. Triscott closed his Boston studio and put its furnishings in storage in the spring of 1902. He still continued to exhibit his works, but not with the fervor that he had in the past. His exhibitions in Boston were confined to a few works at the Art Club in 1905 and about a dozen works at the Boston Society of Water Color Painters shows in 1904, 1905, 1906, and a few less in 1908. This was to mark the end of his exhibits in Boston, save for three works shown by invitation at the thirtieth annual anniversary exhibition of the Boston Society of Water Color Painters in 1919. To this show he sent *The Ledge, Black Head,* and *Gull Rock—Monhegan*. This was a diverse group of pictures, which represented different stylist periods, perhaps painted many years apart, but all of Monhegan.

The Boston Art Club honored Triscott posthumously by showing his watercolor *The Coming Squall* in 1927, hanging it in

the place of honor at the clubhouse. It was "said to be one of the largest watercolors ever painted—5 feet by 3 feet."[87] The Society of Water Color Painters also showed two of his works posthumously at their fiftieth anniversary show held in the Boston Museum of Fine Arts in 1939.

The only other show in which Triscott exhibited was in 1914, when Monhegan celebrated the tercentenary of the voyage of Captain John Smith and of his landing on the island. This festive occasion included an art exhibit which:

> was held in the studio of Bert Poole. The artists participating were Woodhull Adams, George Bellows, Homer Boss, William Broderick, Randall Davey, Mary Roberts Ebert, Charles H. Ebert, George C. Everett, James P. Haney, Eric Hudson, Wilson Irvine, Bert Poole, Karl Schmidt, Alice A. Swett, Alice Stoddard, S. P. Rolt Triscott, Coulton Waugh, and Frederick J. Waugh, all of whom were painting on the island that summer. These names are sufficient to indicate the merit of the pictures shown.[88]

Triscott's contribution to the show was reviewed by an unknown paper: "S. P. R. Triscott, who lives on the Island, sends one broadly treated group of sheep on the apex of a steep rock. The tones are warm gray and the sheep stand in relief against the sky."[89]

For the last twenty years of Triscott's life, he turned to the ever increasing number of Monhegan rusticators for his livelihood. He sold many of his paintings to them, and he and Frank Pierce offered land for cottage lots. He had long since given up his classes in watercoloring; in fact, 1893 was the last year he was listed in the *Boston City Directory* as a teacher of art. However, Lelia Richards Libby, the niece of Triscott's housekeeper, steadfastly maintained that her mother and Aunt Nellie told her that Triscott taught Robert Henri watercolor painting during one of Henri's summer stays on the island. Henri first arrived on Monhegan in

1903 and returned several summers, even buying land on Horns Hill. Henri was impressed with the island. It was through his efforts that Rockwell Kent first went there in 1905, visiting during the summer and returning the following year as a permanent resident.

In the waning days of Triscott's life, he was bothered by poor eyesight, but this did not stop him from painting. Philpott related:

He hadn't been able to do much work in the past few years. His eyes troubled him. He used a magnifying glass when he worked in his studio.

I knew he made two very large pictures about four years ago and when he showed them to me he remarked: "That's about the last shot from the old man." It was rather pitiful.[90]

Lelia Libby recalled visiting Triscott's studio during his last years:

"I must get some money in the studio, then you may go," Mr. Triscott said. I got to my feet silently, and stole in behind him. I had done this before, and he always pretended he did not see me, and so I never saw his roguish twinkle.

There were rows of paintings on the walls, and gilt frames stacked underneath.

"Why, when did you paint that? It wasn't here last week," I burst forth, forgetting our little game. I pointed to the realistic watercolor of White Head crowned with snow.

"Yesterday afternoon." The old man stooped over his billfold, snapping an elastic band in place.

"But," I insisted, "you haven't walked to White Head in years, Mr. Triscott."

With bent head, he was on his way back to the warm living room, while I lingered, standing in rapt attention under the painting.

"Ah, but I can still see the Headland," said Mr. Triscott, softly, as though to himself, and then abruptly in his somewhat gruff voice, "Come Lelia, it's cold in here."[91]

On April 15, 1925, Samuel Peter Rolt Triscott died at the age of seventy-nine on Monhegan Island. He left an estate of $4,557— $1,874 in cash, $1,500 in paintings, and the balance in real estate.[92] His only survivor was thought to be a brother in Heathfield, England. Triscott's death certificate attributed his demise to "dilation of the heart, of several years' duration."[93] Philpott's one-third-page tribute, with a number of photographs, published three days later in the *Boston Globe* tells the story best:

TWO EMINENT PAINTERS FOUND DEAD IN THEIR BEDS
ON SAME DAY—BUT 3,000 MILES APART
JOHN S. SARGENT, AMERICAN, DIED IN ENGLAND, AND
S. P. ROLT TRISCOTT, ENGLISHMAN, SUCCUMBED AS RECLUSE
ON ISLAND OFF MAINE COAST
by A. J. Philpott

Two eminent painters were found dead in their beds last Wednesday morning—one an Englishman; the other an American. The American died in England; the Englishman died in America. Such is destiny!

The American artist—John S. Sargent—was famous in England and America. The English painter was eminent before Sargent was heard of—but not in England. He was known only in America.

Such is fate! Yet it was strange that both men should have died—been found dead in their beds—on the same morning, and without warning—3,000 miles apart. Of course, other people died Wednesday morning—thousands of them the world over—but few of them were artists, and few of them died in just this way.

John S. Sargent died in the heart of London, and his death was a shock to the aristocratic world in which he moved.

S. P. Rolt Triscott, better known as "Trissy," died alone in a bleak house on top of a hill on Monhegan Island, off

the coast of Maine. His death was a shock to the fishermen in the cove below, and an especial shock to Nellie H. Colony [*sic*], a fisherman's wife who lived in the nearest house on the slope below. She suspected that something was wrong when she saw that no smoke issued from the chimney of "Trissy's" house on the Wednesday morning—as it had issued every morning for 20 years or more. Mrs. Colony could almost tell the time of day by that smoke. It was the signal that "Trissy" was up and about and cooking breakfast.

She had a prescience that something was wrong. She went up to the house and found "Trissy" cold in his bed. She, and her husband, and all of the fishermen and their children in the cove below—all of them loved the cheerful, erect, venerable "Trissy" who had not stepped off the island of Monhegan for more than 20 years. He lived in that house on the hill, alone, winters and summers.[94]

Nellie Humphrey Colomy, the sole beneficiary of Triscott's will, and her husband Hiram, better known as "Hite," moved into Triscott's house. With the help of Maud Briggs Knowlton, who owned the cottage north of Triscott's, Nellie inventoried the watercolors, oil paintings, and sketches and found three hundred of them. Mrs. Knowlton, shortly to become the first director of the Currier Gallery of Art in Manchester, New Hampshire, suggested prices that Nellie should ask for the works. These prices attracted buyers for the first few years, but then the depression of the '30s set in, and no more paintings were sold. Nellie had faced the daunting challenge of disposing of three hundred works of art at a time when turn-of-the-century American watercolors were out of favor. She gave a number of the better works to her friends, and when she died she willed two favorites, leaving the balance to her husband. Hite Colomy was not so interested in receiving good prices for the paintings as he was in selling them, and sell them he

did. Many people have told of browsing through piles of pictures on the porch of Triscott's house. Paintings were arranged by size into stacks from which the buyer had a choice of five-, ten-, or fifteen-dollar watercolors, prices that continued through 1947 when the housekeeper's widower died.

S. P. R. Triscott was a watercolor painter in an era when watercolor painters were not held in the highest regard. It seems ironic that Triscott, coming from England where watercolor painting had reached ripe perfection even before he was born with such artists as Constable and Bonington, practiced an art form that was not taken seriously by many in America. Many thought that watercolors were not permanent. Another objection was addressed in the February 4, 1886, issue of *The Nation*:

> There is a common notion that water-color painting is an easier art than painting in oil, which is expressed in the old rhyme:
>
>> La peinture a l'huile
>> Est bien difficile
>> Mais c'est beaucoup plus beau
>> Que la peinture a l'eau.

But *The Nation*, in a rare display of insight concerning watercolor painting in the nineteenth century, concluded:

> But the truth is that the facility of water-color is in its difficulty. The difficulty of attaining full tone or elaborate modeling in water-color approaches impossibility, and the result is that when they are wise, water-color painters hardly attempt these qualities at all....

This attitude continued throughout the nineteenth century, for when Sears Gallagher went abroad for the first time in 1895, he made a series of humorous sketches in Paris, one of which shows the artist with upstretched arms gleefully shouting "harrah" and captioned, "The day of belittling water-color work is past." Thus,

it is not surprising that when the history of American art was written, little attention was given to artists who worked exclusively in watercolor. During the latter part of the nineteenth century, there was an increase in those who took up the medium, but a large number were artists who also worked in oils. Many of the artists who are esteemed today for their watercolors were primarily successful oil painters, and their watercolors did not bring high prices compared to their oils.

The combination of poor public acceptance, a medium in which it was difficult to achieve professional results, and low prices probably did little to enhance watercolor painting as a sole means of support. Even today, the aquarellists listed by Hartmann in his *History of American Art* are not readily recognized by most art historians. It is thus inevitable that S. P. R. Triscott would be relegated to the ranks of forgotten artists.

If all the foregoing were not enough to ensure oblivion, Triscott compounded this by moving from the art circles of Boston at the height of his career to one of the most remote locations in America. There was almost no one, save a few old friends, who knew anything of his past accomplishments, and even they were not privy to all his activities. Triscott was described as, "The most reserved person I ever met," by an elderly Monheganite who became acquainted with him over several years. Triscott was never one to sing his own praises. When called upon to supply information for exhibition catalogues, a typical note would read: "Exhibitor at Boston Art Club and all principal exhibitions" in contrast to other artists who listed every show.

Thus, here was the setting for a perfect example of a phenomenon which John I. H. Baur, director emeritus of the Whitney Museum of American Art, discussed in his introduction to the *M. & M. Karolik Collection of American Paintings*:

This gradual descent into oblivion was aided by an unfortunate reluctance on the part of many American art historians to form independent judgments on the basis of paintings, rather than on earlier published sources.[95]

In the last twenty-five years of his life, Triscott had no major exhibitions of his work, and at the time of his death only a few remembered his earlier fame. This melancholy end was lamentable for an artist credited in his obituary as "having taught watercolor painting to America," whose first one-man show in Boston was described as "the best thing in the way of pure watercolors that has been done in this city for years," and whose last one-man exhibit in Chicago brought the comment "S. P. R. Triscott is pronounced by many critics the most able aquarellist in America."[96]

Samuel Triscott is buried on the island of Monhegan. According to Philpott, "the fishermen in that oldest of fishermen's colonies in America, loved him and when he died they gave him a fisherman's burial and interred his remains soon after sundown, in the little cemetery on the hill under the lighthouse. For he had become one of them in spirit."[97]

About a year before his death, Triscott wrote to a friend who recalled:

> He loved Monhegan and there he died. He sent me a poem, a year ago I think it was, entitled "Abandoned" which shows that he was thinking of the end. There was a pen sketch of the old house on the hill, all gone to ruin, and another of a little grave on the hill.
>
> The last stanza reads:
> *On the Lighthouse Hill in his last retreat—*
> *A weed-grown grave and a broken stone;*
> *East and West at his head and feet*
> *Mark the place where he rests alone.*[98]

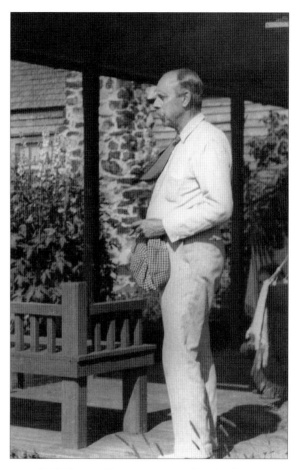

S. P. ROLT TRISCOTT standing in front of his home.
COURTESY OF DOROTHY MALONE

49

1. "The Fine Arts," *Boston Evening Transcript*, April 4, 1892, 6.
2. Ibid.
3. A. J. Philpott, "S. P. R. Triscott, Noted Artist, Dead," *Boston Globe*, April 15, 1925.
4. "Mr. Triscott's Water-Colors," *Boston Daily Advertiser*, December 24, 1881.
5. *Boston Globe*, April 30, 1882, 3.
6. *Boston Globe* art critic A. J. Philpott stated in three articles that Triscott gave Homer instruction in watercolor painting: *Boston Globe*, March 19, 1939, and November 3, 1944; undated *Boston Globe* article entitled, "Watercolors of Homer, Sargent, McKnight Form Museum Show."
7. *Chicago Times Herald*, December 3, 1899.
8. Family information is abstracted from two genealogical research reports prepared by Peter W. Watson of East Anglian Village Research, Dedham, Essex, England (July 17, 2000; November 2, 2000). In *Who's Who in America* from 1901 until his death in 1925, Triscott stated that he had received "general education private school; educated as civil engineer and studied art in England."
9. In the *American Art Annual* from 1907 until his death in 1925, Triscott cited Philip Mitchell (1814–96) and the Royal Institute of Painters in Water Colors in London as the sources of his training as an artist. A member of the Royal Institute, Mitchell spent his life on the southern coast of England, the region of Triscott's birth and childhood. Philip Mitchell was born in Devonport and received his first art instruction from an older brother who painted miniatures. At the age of fourteen, he went to Falmouth, where he painted with two watercolor artists, Philip and Williams. He may have served in the navy during his teens. In the record of his marriage to Louisa Vavasour in 1838, Mitchell was identified as an artist. The Mitchells settled in Plymouth in 1845, where he spent the balance of his life painting watercolors. Much of his work depicted coastal scenes, but he favored inland landscapes during the latter part of his career. He became an associate of the Royal Institute in 1854 and a full member in 1879. George Pycroft's 1883 book *Art in Devonshire* described Mitchell as "one of our leading Devonshire landscape painters." During Triscott's formative years, Mitchell was a well-established artist in southern England, and his preference for maritime subjects was to have a lasting effect on his pupil. Triscott's connection to the Royal Institute remains unclear. The Institute has no record of his attending classes or exhibiting there, and he was not a member.
10. While Triscott's 1888 petition for naturalization states that he arrived in New York City "on or about" March 10, 1871, the *New York Times* for March 10, 1871, lists him as a passenger on the steamship CHINA, which arrived on March 9. (Records of Naturalization, U. S. District Court, Boston, vol. 192, 152.) Included on the passenger list were Mr. and Mrs. George A. Wheeler. ("Passengers Arrived," *New York Times*, March 10, 1871, 8.). Manifest of the CHINA, Port of New York, March 10, 1871, includes "Samuel P. Triscott, 25, Civil Engineer, England" (Ship Passenger Arrival Records, National Archives).
11. Dated 1874, *Merrimac River Near Franklin Falls* is in a private collection.
12. *A Wood Boat* is owned by the Museum of Fine Arts, Boston.
13. *Fine-Art Department, Twelfth Exhibition of the Massachusetts Charitable Mechanic Association*, Boston, 1874, 11.
14. Richard H. Malone's Triscott research files in the possession of Dorothy Malone.
15. The 1873 *Worcester City Directory* listed George A. Wheeler and Samuel P. Triscott as civil engineers at 379 Main Street. From 1874 through 1879 Triscott was listed alone as a civil engineer at 387 Main Street. The 1880 directory noted that he had "removed to Boston." The 1879 *Boston City Directory* listed Triscott as a civil engineer living at 2 Harvard Place. There was no 1880 listing for him, but he reappeared in 1881 as an artist at 81 Milk Street.
16. A. J. Philpott, "Sears Gallagher's Paintings Shown," *Boston Globe*, December 4, 1933.
17. Richard H. Malone, draft of a letter to Lloyd Goodrich, Triscott research files in the possession of Dorothy Malone.
18. An example of Triscott's influence as a teacher is found in an undated *Boston Sunday Journal* article entitled, "Sears Gallagher, One of Boston's Well-Known Illustrators and His Art Work," which was reprinted in the *West Roxbury News*: "His first real hints for color work were secured from S. P. R. Triscott, a leading color artist. Mr. Triscott assisted the young man materially in his work, and Gallagher made rapid progress."
19. *Boston Daily Advertiser*, December 20, 1883, 4.
20. *Boston Post*, December 8, 1882, 2.
21. *Boston Sunday Globe*, December 10, 1882, 3.
22. Ibid.
23. *Boston Evening Transcript*, December 11, 1882, 6.
24. Ibid.
25. A native of Grafton, Massachusetts, William Ladd Taylor (1854–1926) studied at the Académie Julian in Paris in 1884–85 and became an illustrator for such popular magazines as the *Ladies Home Journal*.
26. *Boston Herald*, February 3, 1886, 4.
27. *Boston Evening Transcript*, December 20, 1883, 3.

28. *Boston Post*, December 21, 1883, 2.
29. Ibid.
30. *Boston Daily Advertiser*, March 17, 1885, 2.
31. *Exhibition and Private Sale of Water Colors by S. P. Rolt Triscott at the Gallery of J. Eastman Chase, 7 Hamilton Place, March 13th to 28th (1885).*
32. *Boston Herald*, March 15, 1885, 8.
33. Ibid.
34. Ibid.
35. *Boston Evening Transcript*, March 18, 1885, 6.
36. *Boston Daily Advertiser*, December 1, 1885, 4. and February 9; 1885, 5; *Providence Journal*, April 17, 1885, 8.
37. *Boston Daily Advertiser*, December 1, 1885, 4.
38. *Boston Evening Transcript*, February 5, 1886, 6.
39. Ibid.
40. *Boston Sunday Globe*, February 7, 1886.
41. Ibid.
42. *Boston Daily Advertiser*, February 6, 1886, 2.
43. *Boston Herald*, March 13, 1887, 8.
44. *Boston Evening Transcript*, March 15, 1887.
45. *Boston Herald*, March 24, 1892, 4.
46. *Boston Post*, April 17, 1889, 4.
47. *Boston Daily Advertiser*, December 11, 1888, 4.
48. *Boston Evening Transcript*, April 10, 1889, 11.
49. *Boston Post*, April 17, 1889, 4.
50. *Chicago Tribune*, March 24, 1891.
51. Boston Art Club's Forty-Fourth Annual Watercolor Exhibition, April 4–25, 1891.
52. *Boston Evening Transcript*, March 23, 1892, 6.
53. "The Fine Arts," *Boston Evening Transcript*, April 4, 1892, 6.
54. A native of Maintz, Germany, William

A. J. Claus (1862–1926) studied painting at the Museum School of the Boston Museum of Fine Arts and the Académie Julian in Paris. Claus established himself as an artist in Boston in 1887 and spent the next four decades specializing in portraiture and teaching painting. In 1899 he acquired half ownership of the east side of "The Influence" on Monhegan Island, which he used as a summer home and studio. Claus enjoyed a long, close friendship with Triscott, which is reflected in his serving as the principal witness to Triscott's will in 1923.
55. "Sears Gallagher Passes Summers Painting on Monhegan Island."
56. *Boothbay Register*, August 20, 1892: "Among those stopping at the Albee House are … Mr. S. P. R. Trescott [sic], the well-known artist, of Boston."
57. A. J. Philpott, "Sears Gallagher Loves Monhegan," *Boston Globe*, March 19, 1939.
58. A. J. Philpott, "Two Eminent Painters Found Dead in Their Beds on Same Day — But 3,000 Miles Apart," *Boston Globe*, April 18, 1925.
59. A. J. Philpott, "Romances of 2 Artists Have Proved Intriguing," *Boston Globe*, November 3, 1944.
60. *Pemaquid Messenger*, August 31, 1893: "Mr. Samuel P. R. Trescott [sic] of Boston has purchased the George Pierce house and is repairing it for a summer cottage."
61. "Pictures Old and New," *New York Daily Tribune*, November 19, 1893, 22.
62. "The Fine Arts," *Boston Evening Transcript*, April 23, 1894, 7.
63. *Boston Herald*, April 22, 1894.
64. Records of Naturalization, U. S. District Court, Boston, vol. 192, 152.
65. A. J. Philpott, "Two Eminent Painters Found Dead in Their Beds on Same Day— But 3,000 Miles Apart," *Boston Globe*, April 18, 1925.

66. *Chicago Times Herald*, May 10, 1896.
67. S. P. Rolt Triscott to William Macbeth, Monhegan, Maine, November 20, 1898, Macbeth Gallery correspondence with artists, circa 1894–1914, Archives of American Art.
68. Last Will and Testament of S. P. R. Triscott, Monhegan, Maine, June 21, 1923, Lincoln County Registry of Probate, Wiscasset.
69. Clark and Clark to Triscott and McClure, July 28, 1897, Lincoln County Registry of Deeds, Wiscasset, Book 302, page 14.
70. S. P. R. Triscott to William Macbeth, Monhegan, Maine, November 20, 1898, Macbeth Gallery correspondence with artists, circa 1894–1914, Archives of American Art.
71. *The Poetical Works of Lord Byron*, London, 1935, page 243.
72. Tenth Exhibition of the Boston Society of Water Color Painters, February 1 to February 12, 1898.
73. "Art Club's Exhibition," *Boston Transcript*, April 2, 1898, 15.
74. *Chicago Times Herald*, December 3, 1899.
75. Ibid.
76. Sadakichi Hartmann, *A History of American Art*, Boston, 1901, vol. 1, 109.
77. Rockwell Kent, *It's Me, O Lord*, New York, 1955, 151–54.
78. *Proceedings of the Worcester Historical Society*, New Series, 1935, vol. 2, 90.
79. "Following Trail of Three Centuries on Monhegan," *Lewiston Evening Journal*, August 6, 1914.
80. A. J. Philpott, "Two Eminent Painters Found Dead in Their Beds On Same Day— But 3,000 Miles Apart," *Boston Globe*, April 18, 1925.
81. Lelia Richards Libby, "Childhood Services for Monhegan Artist Most Rewarding

Even Now," *Lewiston Evening Journal*, July 30, 1960.

82. "Following Trail of Three Centuries on Monhegan," *Lewiston Evening Journal*, August 6, 1914.

83. Lelia Richards Libby, "Childhood Services for Monhegan Artist Most Rewarding Even Now," *Lewiston Evening Journal*, July 30, 1960.

84. Richard H. Malone's Triscott research files in the possession of Dorothy Malone.

85. Lelia Richards Libby, "Childhood Services for Monhegan Artist Most Rewarding Even Now," *Lewiston Evening Journal*, July 30, 1960.

86. *Boston Society of Water Color Painters, Fourteenth Exhibition, 1902*, annotated copy in the collection of the Museum of Fine Arts, Boston.

87. Lelia Richards, "The Artist and the Island Child," *Lewiston Evening Journal*, January 1, 1938.

88. Charles Francis Jenney, *The Fortunate Island of Monhegan*, Worcester, 1922, 66.

89. Richard H. Malone's Triscott research files in the possession of Dorothy Malone.

90. A. J. Philpott, "Two Eminent Painters Found Dead in Their Beds on Same Day—But 3,000 Miles Apart," *Boston Globe*, April 18, 1925.

91. Lelia Richards, "The Artist and the Island Child," *Lewiston Evening Journal*, January 1, 1938.

92. Last Will and Testament of S. P. R. Triscott and related probate records, Lincoln County Registry of Probate, Wiscasset.

93. Ibid.

94. A. J. Philpott, "Two Eminent Painters Found Dead in Their Beds on Same Day—But 3,000 Miles Apart," *Boston Globe*, April 18, 1925.

95. John I. H. Baur, "Trends in American Painting," *M. and M. Karolik Collection of American Paintings 1815 to 1865*, Boston, 1949, xxxv.

96. A. J. Philpott, "S. P. R. Triscott, Noted Artist, Dead," *Boston Globe*, April 15, 1925; "Mr. Triscott's Water-Colors," *Boston Daily Advertiser*, December 24, 1881; *Chicago Times Herald*, December 3, 1899.

97. A. J. Philpott, "Sears Gallagher Loves Monhegan," *Boston Globe*, March 19, 1939.

98. A. J. Philpott, "Two Eminent Painters Found Dead in Their Beds on Same Day—But 3,000 Miles Apart," *Boston Globe*, April 18, 1925.

The Paintings

Untitled, 1874. Oil on canvas, 16⅜ x 26¼.

Merrimac River near Franklin Falls, New Hampshire, 1874. Watercolor on paper, 13 x 18.

Nancy Malone Appleton

Lake Quinsigamond, Massachusetts, 1878. Watercolor on paper, 7¾ x 16¾.

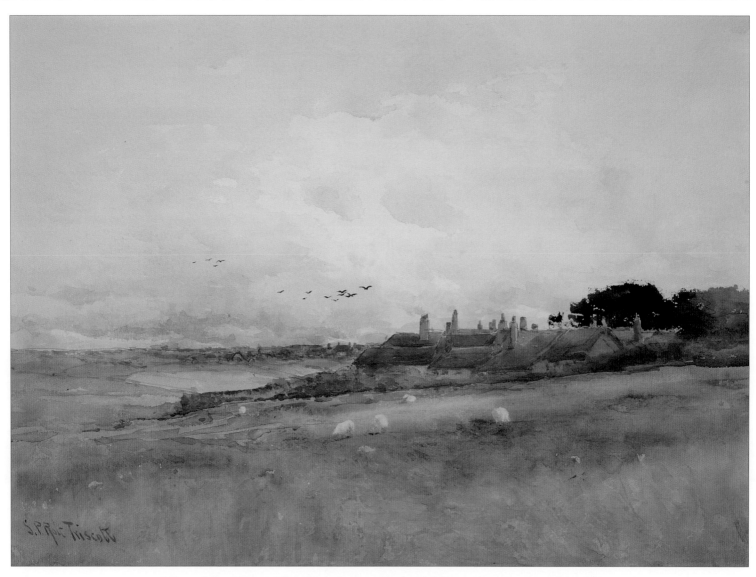

Edge of the Village, Chagford, Devon, England. Watercolor on paper, 16 x 22.
Earle G. Shettleworth, Jr.

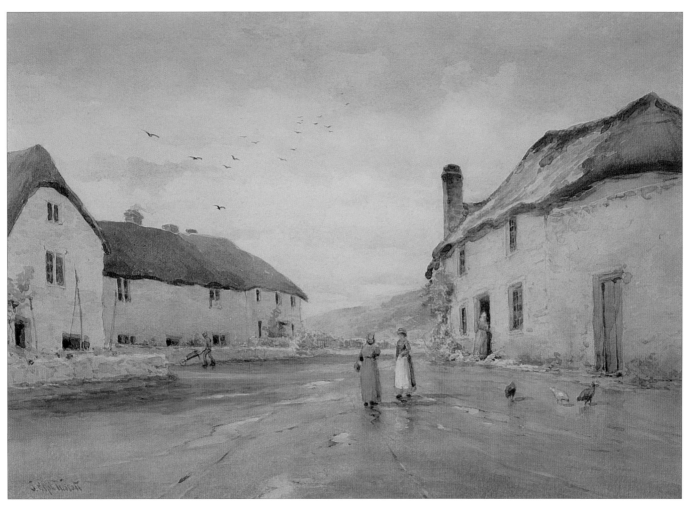

Village in Devon, England. Watercolor on paper, 10¾ x 15¼.
EARLE G. SHETTLEWORTH, JR.

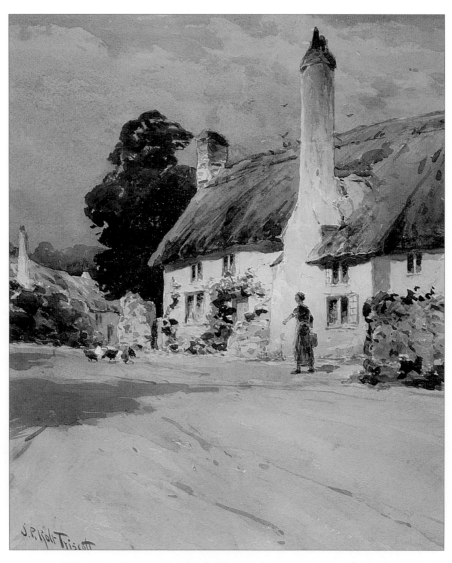

Village in Devon, England. Watercolor on paper, 11¾ x 10.
DOROTHY MALONE

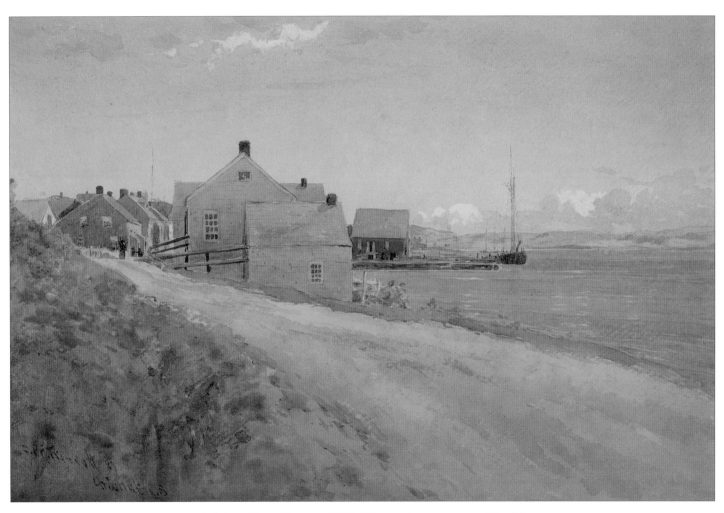

Arichat, Cape Breton, 1883. Watercolor on paper, 12 x 18.
SHEILA KOUGHAN

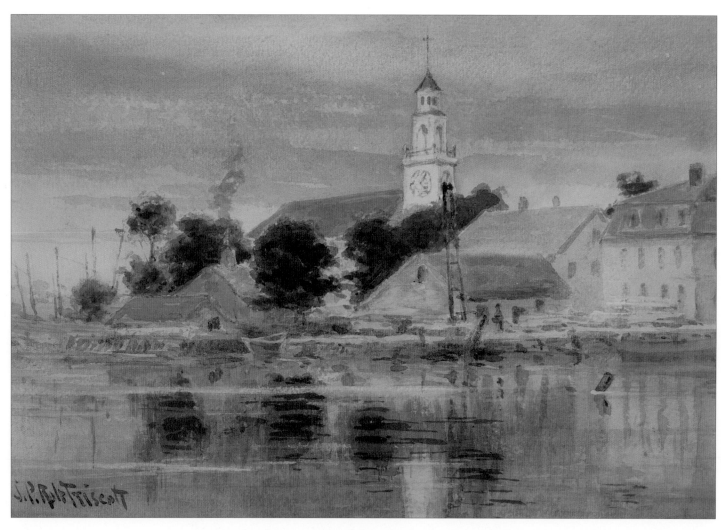

Kennebunkport, Maine. Watercolor on paper, 9 x 12½.
MONHEGAN MUSEUM

Beach, Ogunquit, Maine. Watercolor on paper, 15 3/16 x 30 3/16.
Thomas Hinkle

Looking Up Long Pond, Mount Desert, 1879. Watercolor on paper, 5 ½ x 14.

<small>REMAK RAMSAY</small>

Inlet on the Maine Coast. Watercolor on paper, 14 ½ x 29.

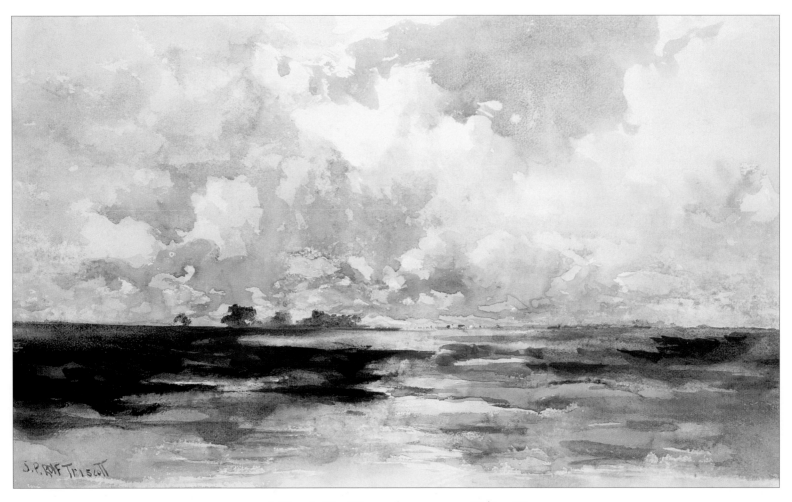

A Cloudy Sky. Watercolor on paper, 12 ½ x 20.
MONHEGAN MUSEUM

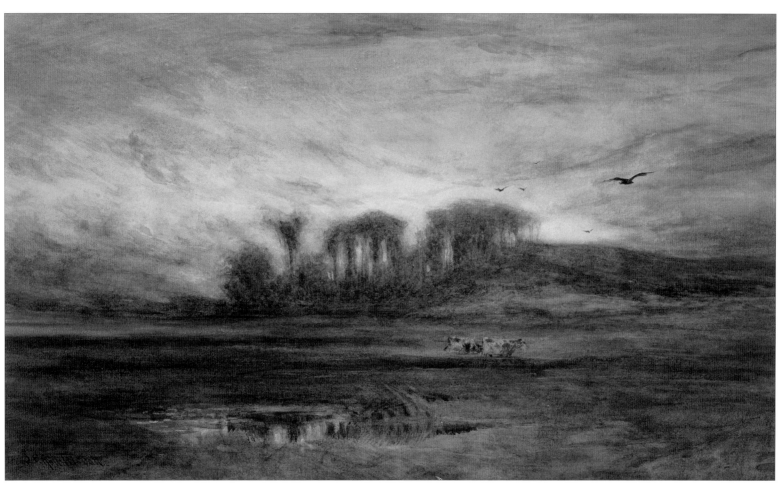

Sunset on the Marsh. Watercolor on paper, 16 ¼ x 27 ¼.
Dorothy Malone

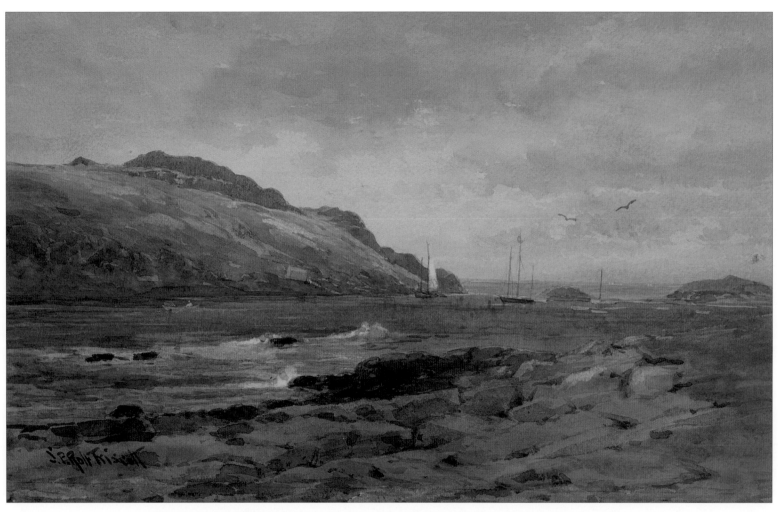

Manana Island and Monhegan Harbor, March, 1897. Watercolor on paper, 13 x 20.
KEITH P. MALONE

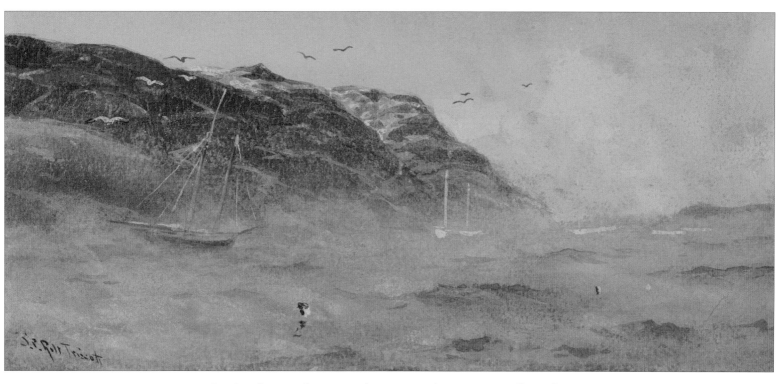

Sea Smoke, Monhegan Harbor. Watercolor on paper, $3\frac{7}{8}$ x $8\frac{3}{8}$.

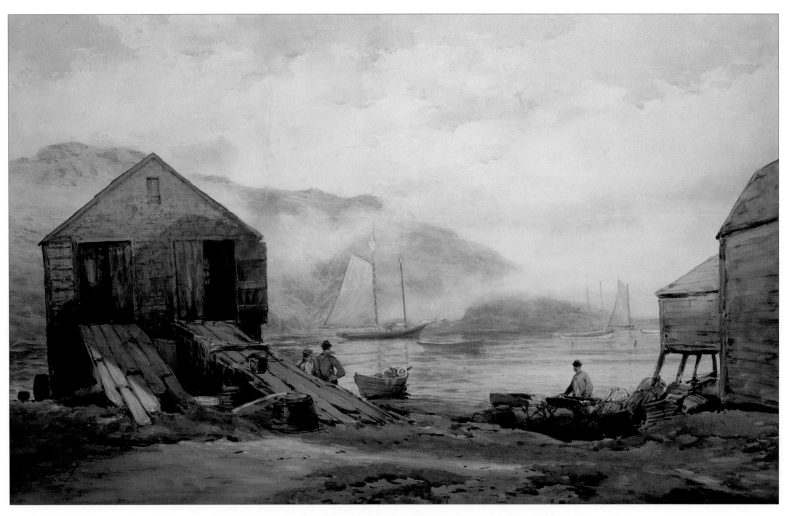

Manana Island—Monhegan: Sunrise. Watercolor on paper, 22 x 36.
DOROTHY MALONE

Monhegan Village from Horn's Hill. Watercolor on paper, 14½ x 20½.
Sheila Koughan

Monhegan Village in Winter, January, 1898. Watercolor on paper, 16 x 27.
James Wyeth

70

Monhegan Village from Horn's Hill. Watercolor on paper, 13¾ x 19¾.
SALLY W. RAND

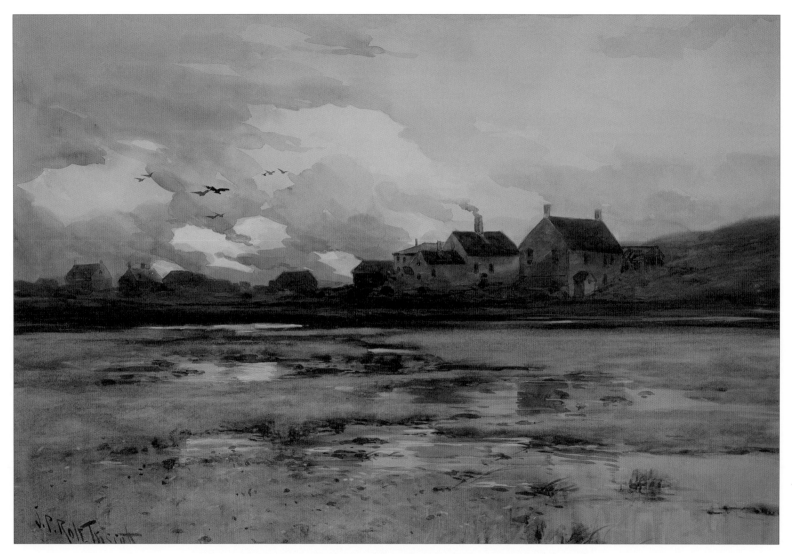

Across the Marsh, Monhegan Island. Watercolor on paper, 13¾ x 20.
Dorothy Malone

The Pink House, Monhegan Village, December, 1896. Watercolor on paper, 14½ x 21½.
SALLY W. RAND AND EARLE G. SHETTLEWORTH, JR.

Stormy Day, Monhegan Village. Watercolor on paper, 16 x 20.
SHEILA KOUGHAN

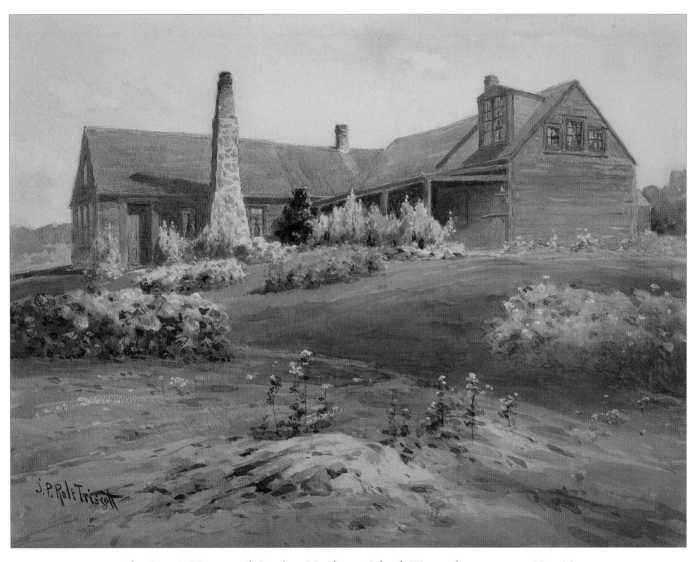

The Artist's House and Garden, Monhegan Island. Watercolor on paper, 11 x 14.
DOROTHY MALONE

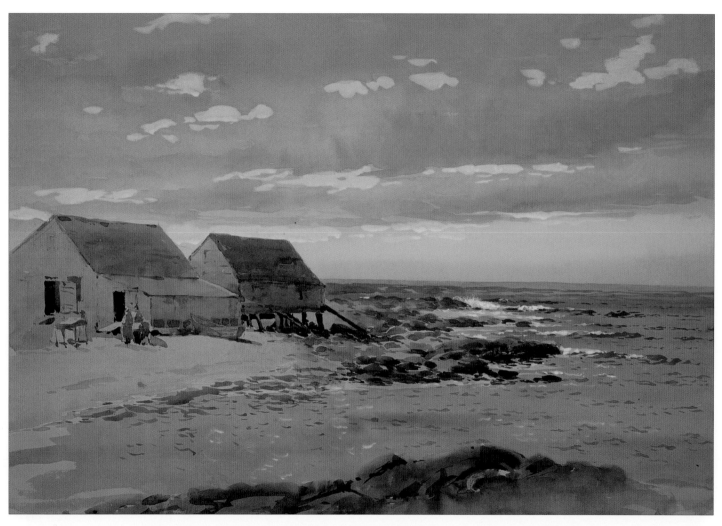

Fish Houses, Fish Beach, Monhegan Island. Watercolor on paper, 13½ x 20¾.
EARLE G. SHETTLEWORTH, JR.

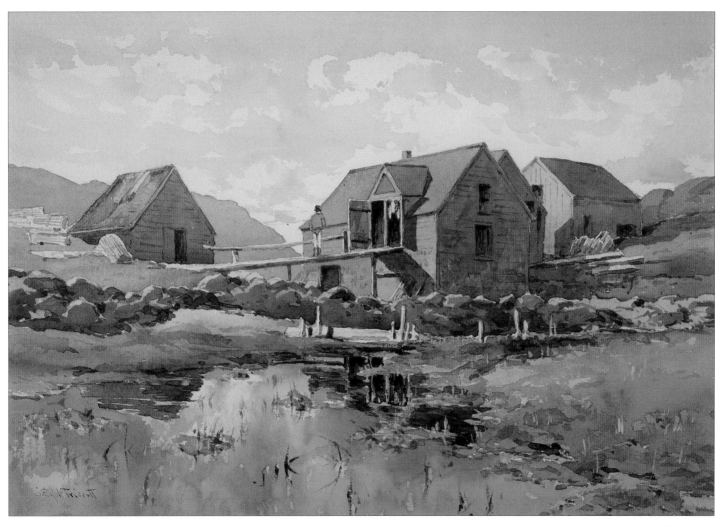

Stanley Fish House, Trefethren Barn, Starling Fish Houses, Monhegan Village. Watercolor on paper, 9½ x 13½.
EARLE G. SHETTLEWORTH, JR.

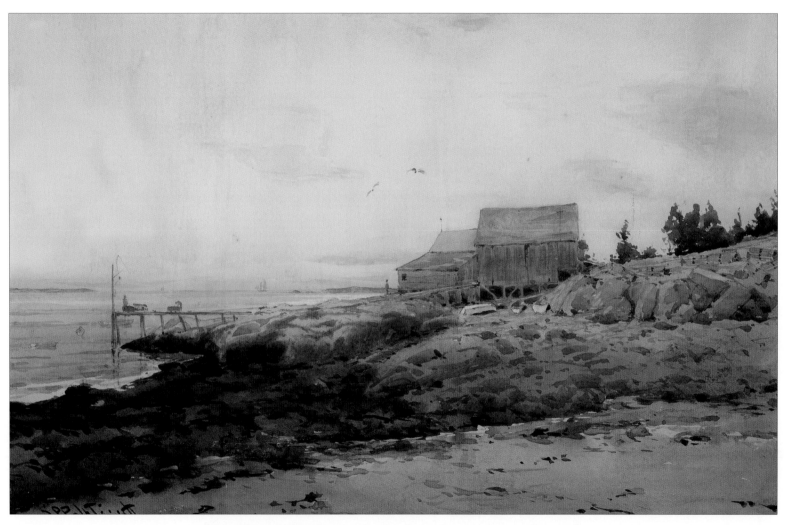

The Wik-Wak, Monhegan Island. Watercolor on paper, 13¾ x 20¾.
SHEILA KOUGHAN

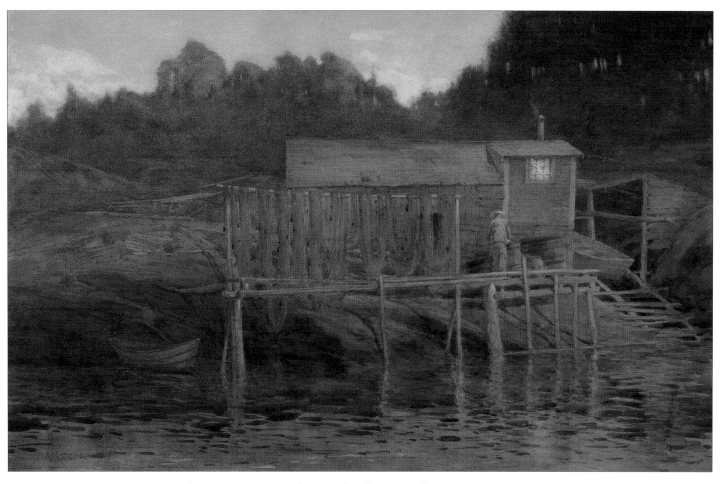

The Hermitage, Monhegan Island. Watercolor on paper, 23 x 37.

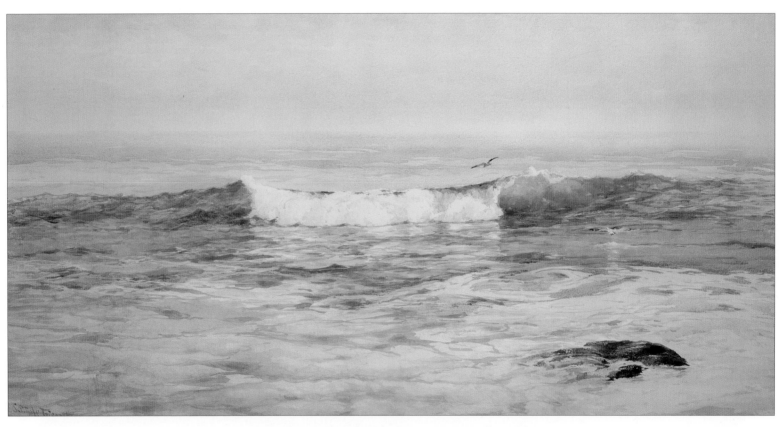

A Sunken Ledge. Watercolor on paper, 18 ¾ x 36.
NANCY MALONE APPLETON

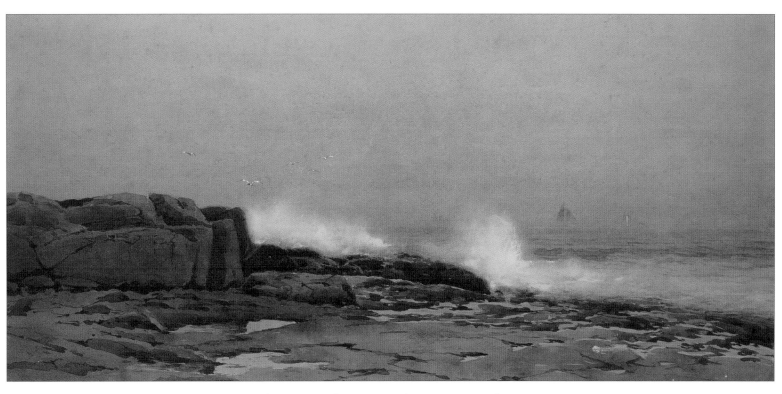

Gloomy Weather. Watercolor on paper, 10¾ x 23.
SHEILA KOUGHAN

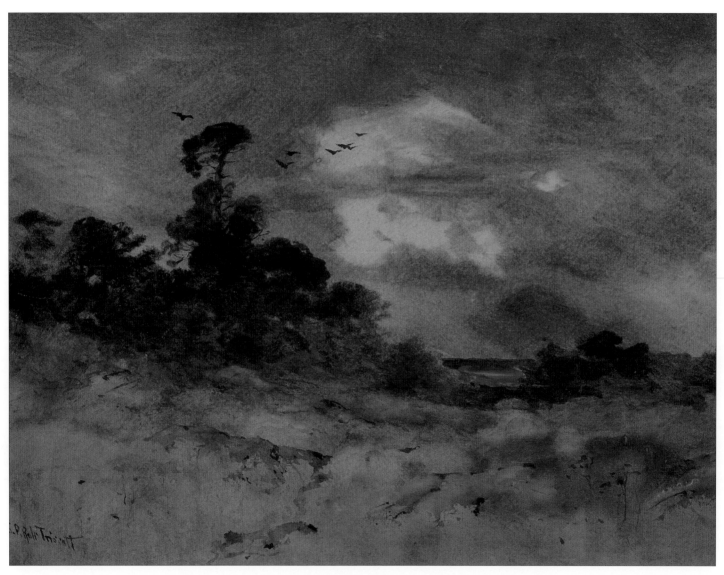

The Crow's Nest, Monhegan Island. Watercolor on paper, 9 x 12.
Dorothy Malone

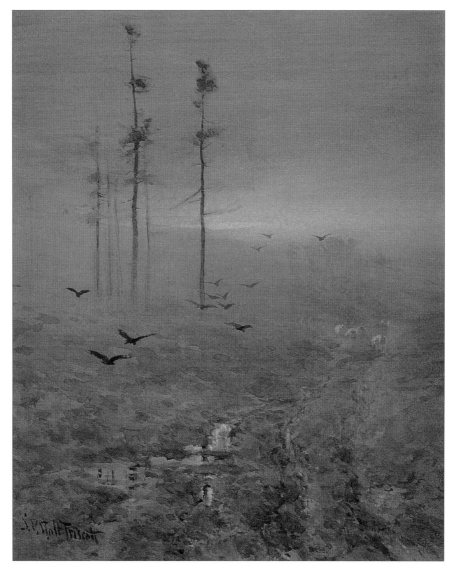

The Crow's Nest, Monhegan Island. Watercolor on paper, 12½ x 10.
Dorothy Malone

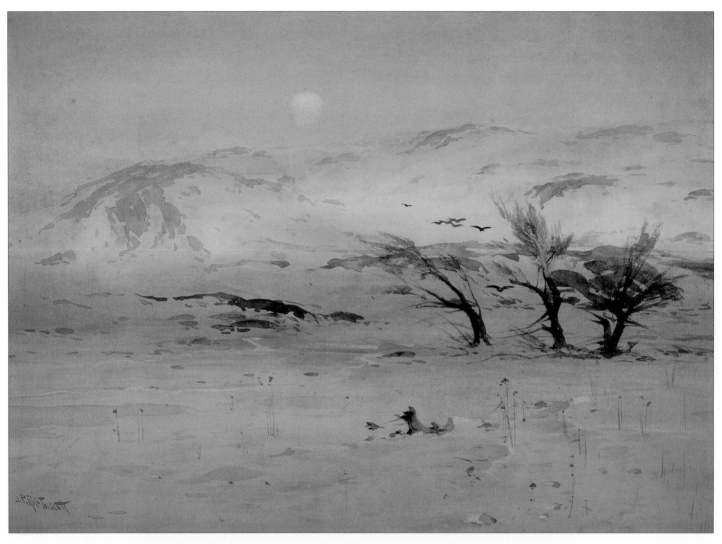

A Bright Day, Monhegan Island. Watercolor on paper, 14¾ x 19¾.
NANCY MALONE APPLETON

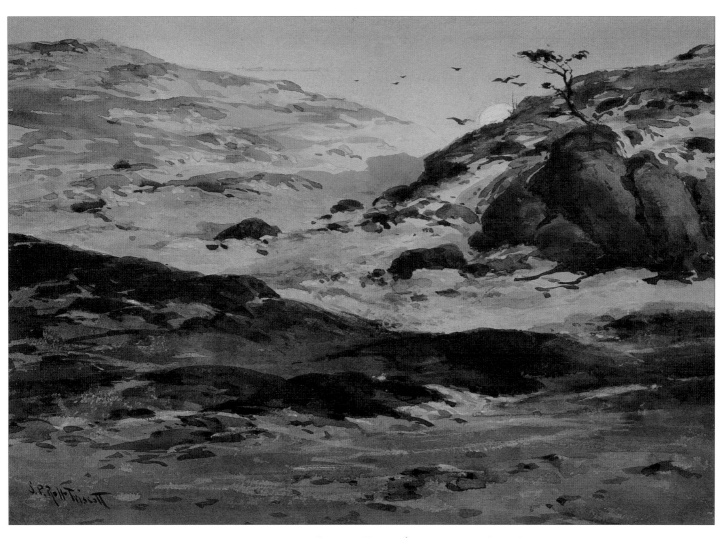

Winter Moonrise at Sunset. Watercolor on paper, 10 x 14.
DOROTHY MALONE

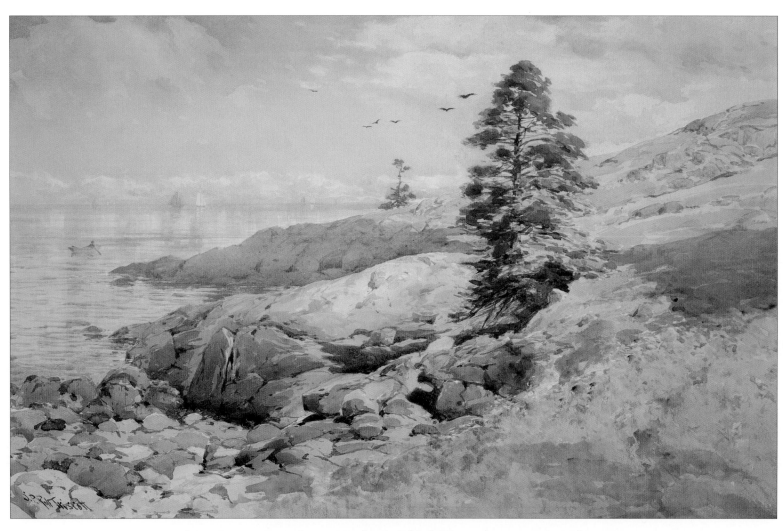

A Quiet Day at Green Point, Monhegan Island. Watercolor on paper, 17½ x 28.

DOROTHY MALONE

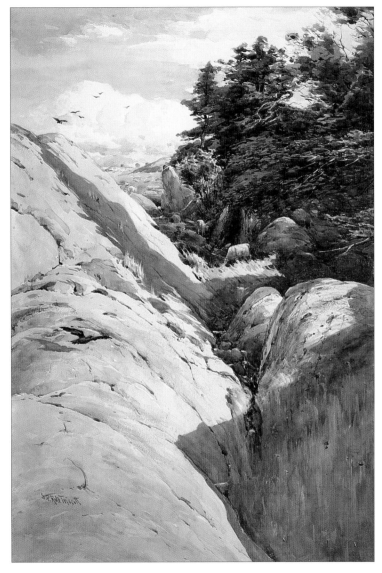

A Gully, Monhegan Island. Watercolor on paper, 24 x 16 ½.
DOROTHY MALONE

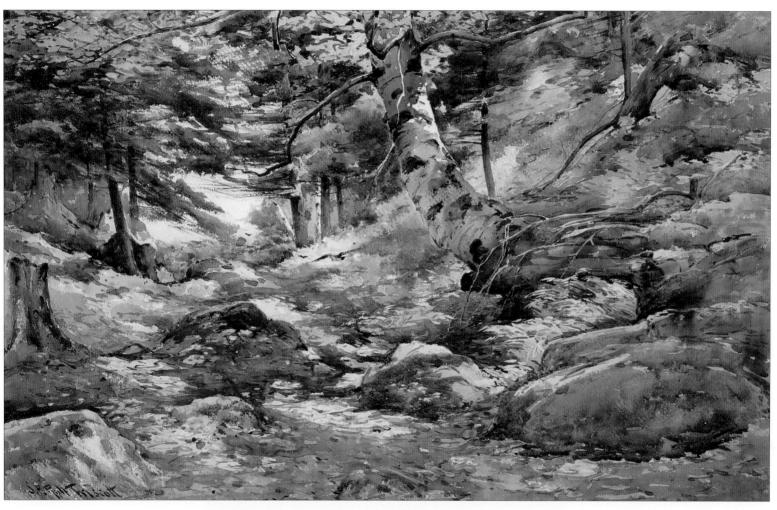

Woods, Monhegan Island. Watercolor on paper, 17¾ x 27¾.

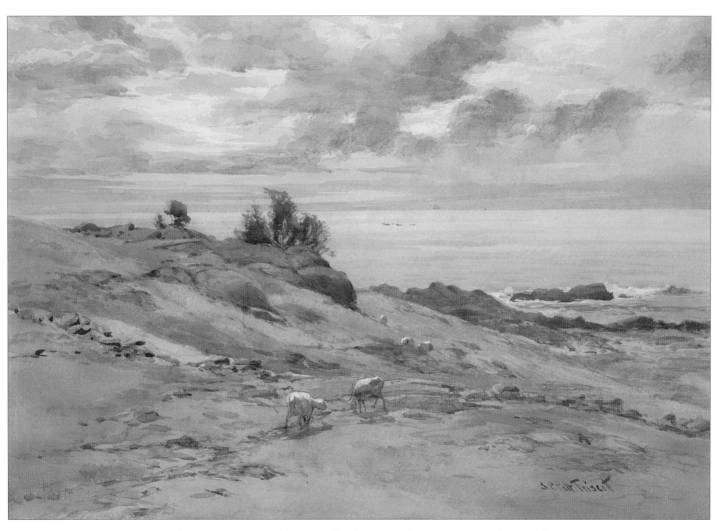

Sheep Grazing, Monhegan Island. Watercolor on paper, 13½ x 19½.
JAMES WYETH

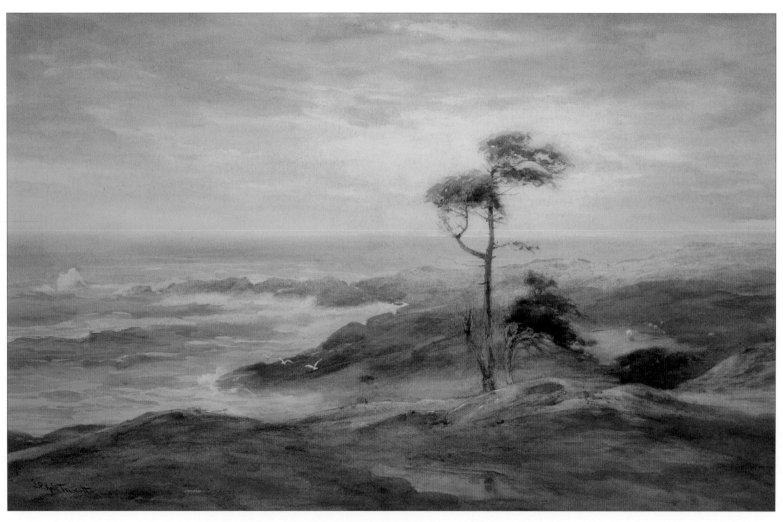

Lone Tree, Monhegan Island. Watercolor on paper, 19 x 30½.
Monhegan Museum

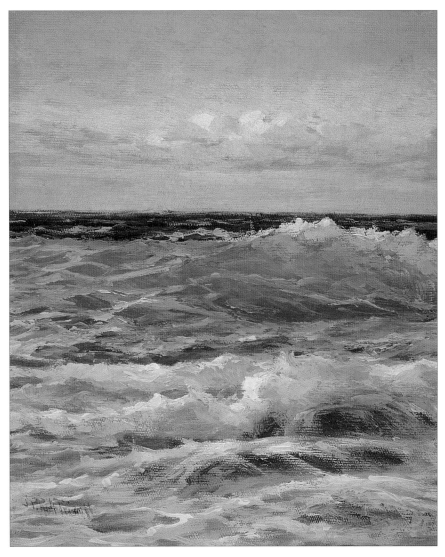

Beyond Lobster Cove, Monhegan Island. Oil on canvas, 12 x 10.
EDWARD L. DECI

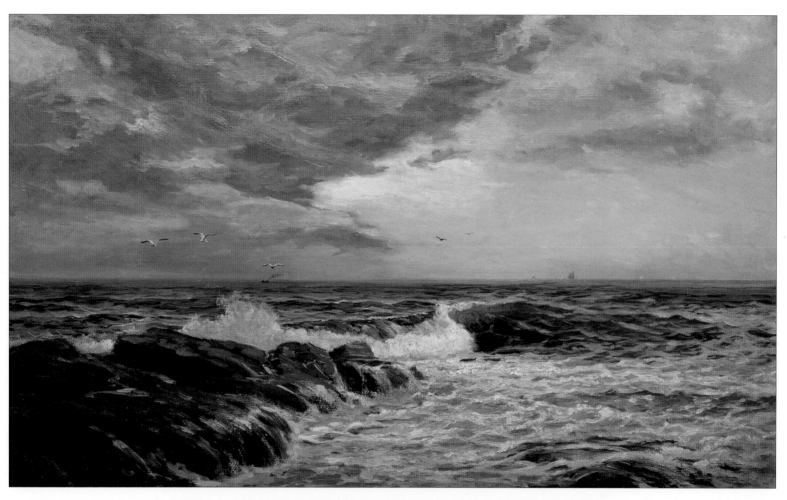

Surf, Monhegan Island. Oil on canvas, 16½ x 27½.
MONHEGAN MUSEUM

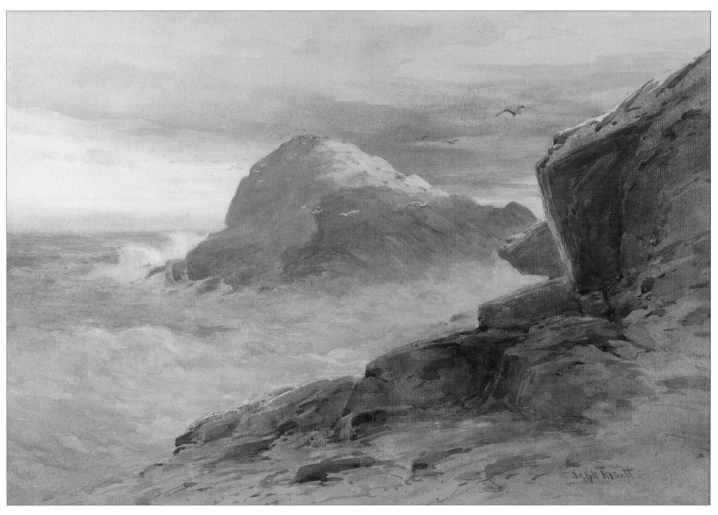

Gull Rock, Monhegan Island. Watercolor on paper, 14 x 20½.

Edward L. Deci

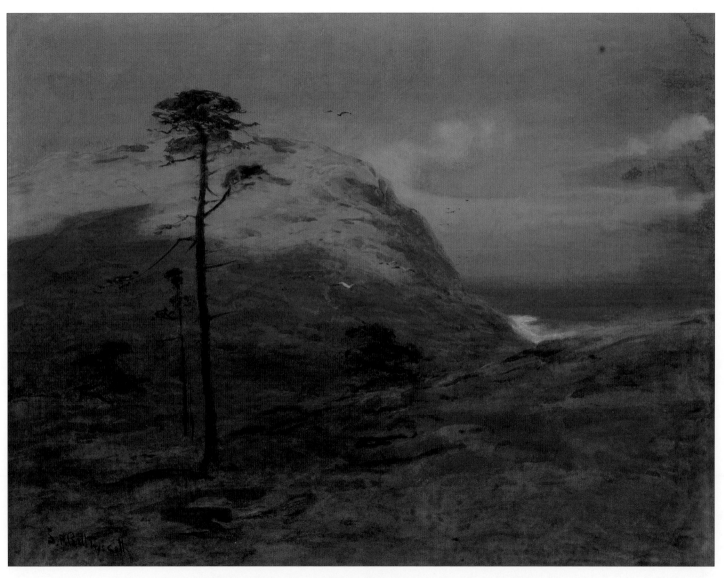

Evening, White Head, Monhegan Island. Watercolor on paper, 11 x 14.
EDWARD L. DECI

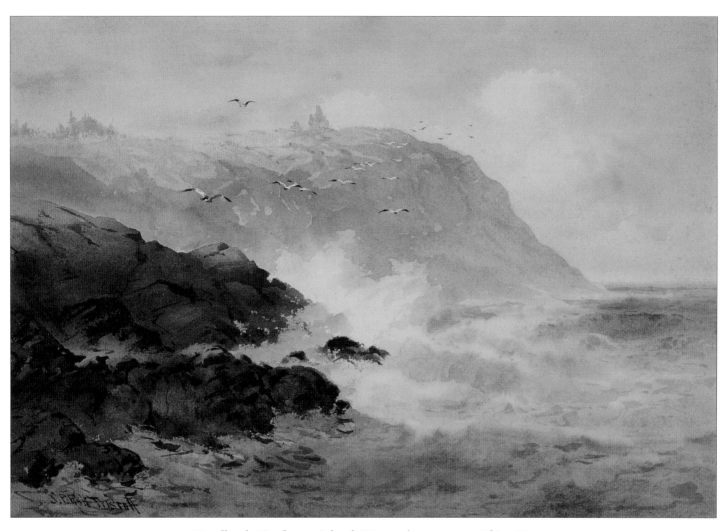

Headland, Monhegan Island. Watercolor on paper, 9½ x 14.
JACQUELINE BOEGEL AND WILLARD BOYNTON

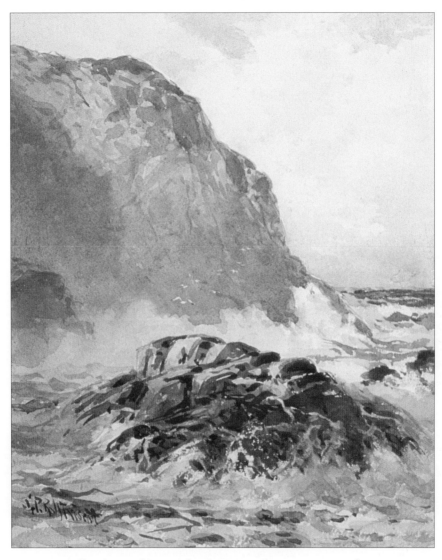

Headland, Monhegan Island. Watercolor on paper, 11¾ x 9.

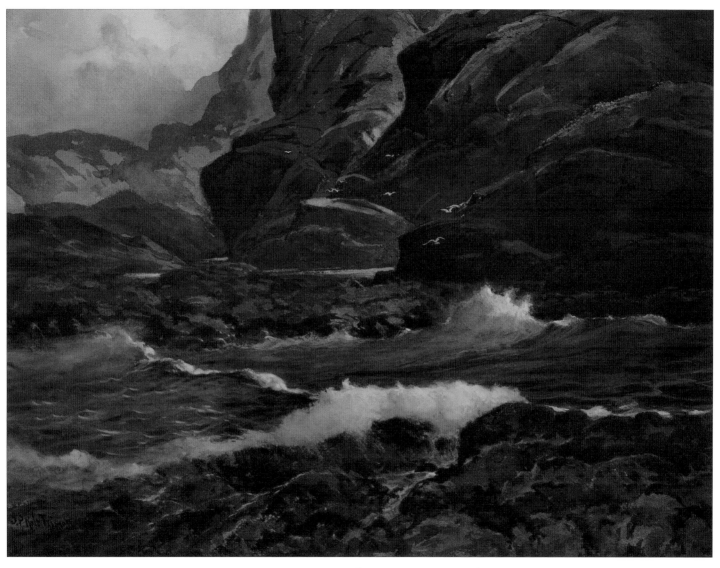

Maine Coast. Watercolor on paper, 19 x 25½.
DOROTHY MALONE

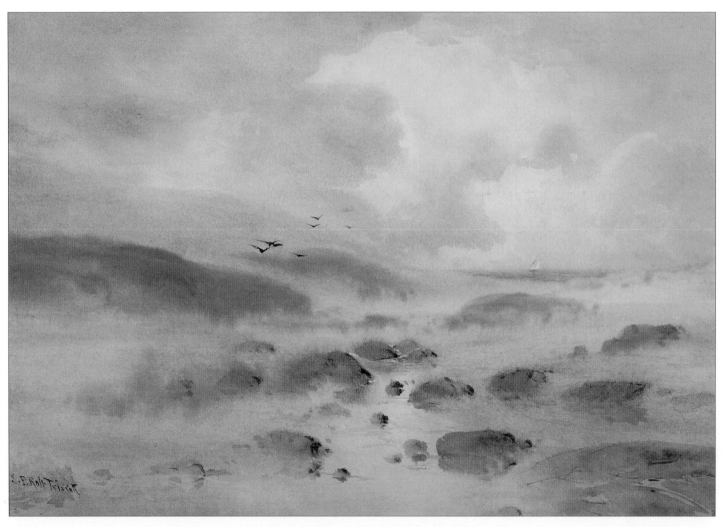

Sea Smoke. Watercolor on paper, 14 x 20.

Earle G. Shettleworth, Jr.

WHEN S. P. ROLT TRISCOTT died on April 15, 1925, he left his estate to his housekeeper Nellie Humphrey Colomy. In addition to his home and three hundred paintings, Mrs. Colomy inherited the artist's photographic equipment and a large number of glass negatives of Monhegan Island scenes. The equipment and negatives soon went to Josephine Davis Townsend, a young photographer who had assisted Triscott in making prints and enhancing them with overpainting. Townsend printed thirty of the negatives for herself and then carefully stored all of them in boxes, interleafing each one with a carefully cut piece of newspaper to protect against damage. Decades later she gave one box to the Monhegan Museum, but she kept the balance of the collection until her death in 1981. The Triscott negatives then descended in her family until they were acquired by the Maine Historic Preservation Commission in 1998. What Josephine Davis Townsend pre-

The Role of Photography in the Art of S. P. Rolt Triscott

by Earle G. Shettleworth, Jr.

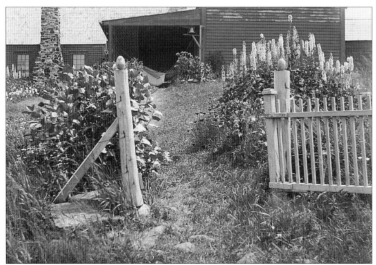

PHOTOGRAPH OF THE ENTRANCE to Triscott's garden.
COURTESY OF THE MAINE HISTORIC PRESERVATION COMMISSION

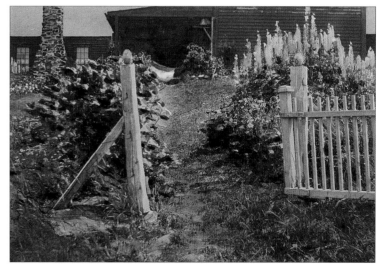

OVERPAINTED PHOTOGRAPH OF THE ENTRANCE to Triscott's garden.
COURTESY OF THE MONHEGAN MUSEUM

served is an extraordinary body of photographic work by a major New England painter. These negatives, combined with original prints and other material, make it possible to reconstruct the role which photography played in Triscott's artistic career.

The introduction of the dry plate process in the early 1880s enabled photographers to work more freely in the field. The result, as William F. Robinson has observed in *A Certain Slant of Light*, was "the evergrowing band of amateur and professional photographers who began using the camera for their own artistic expression." Between Triscott's first visit to Monhegan in 1892 and the publication of his photographs as illustrations for A. G. Pettengill's article "Monhegan, Historical and Picturesque" in the September

PHOTOGRAPH OF SURF crashing on a sunken ledge, Monhegan Island.
COURTESY OF THE MAINE HISTORIC PRESERVATION COMMISSION

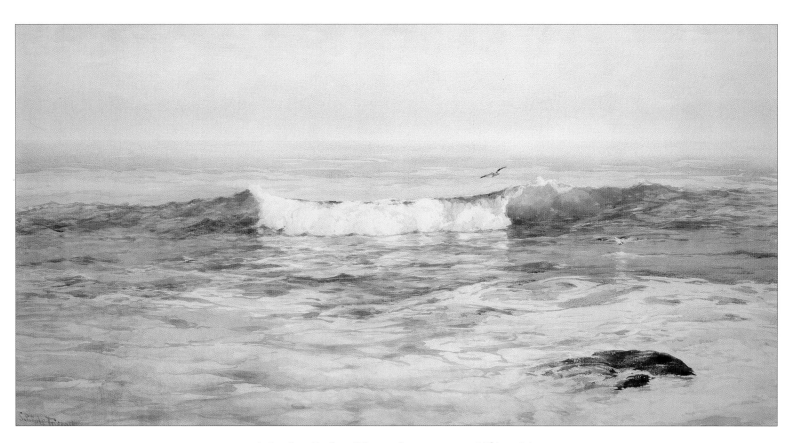

A Sunken Ledge. Watercolor on paper, 18 3/4 x 36.
Courtesy of Nancy Malone Appleton

PHOTOGRAPH OF A GULLY on Monhegan Island.
COURTESY OF THE MAINE HISTORIC PRESERVATION COMMISSION

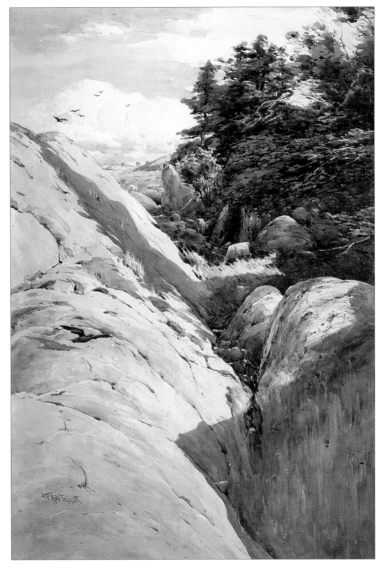

A Gully, Monhegan Island. Watercolor on paper, 24 x 16 $^1/_2$.

1898 issue of the *New England Magazine*, the artist took many pictures of the harbor, the village, its people, and the dramatic island scenery. He was joined in this pursuit by his close friend and fellow painter William Claus, whose photographs also appeared in the *New England Magazine* article along with Frank Myrick's sketches.

Triscott and Claus probably were the first artists to make extensive use of photography on Monhegan, both as an art form in its own right and as a means of capturing subjects for paintings. Triscott's pre-1900 photographs of the local fishermen, their harbor fish houses, and their village homes share the refreshingly direct quality of Eric Hudson's genre photographs of the same subject matter made between 1897 and 1900. In contrast, when Triscott turned his camera to such natural features as Monhegan's meadows, woods, coves, and headlands, the results were more painterly.

PHOTOGRAPH OF SURF on Swim Beach, Monhegan Island. COURTESY OF THE MAINE HISTORIC PRESERVATION COMMISSION

POSTCARD ENTITLED "Fish Houses and Surf, Monhegan, Me.," circa 1905. COURTESY OF THE MAINE HISTORIC PRESERVATION COMMISSION

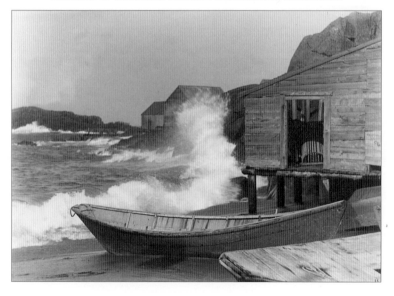

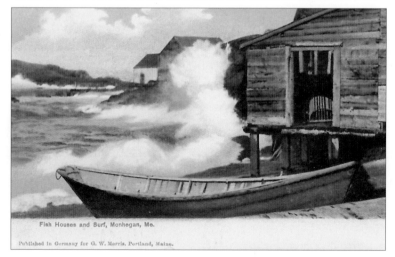

After 1900 he took this approach a step further by creating dramatic impressionistic photographs of cliffs and surf. Unlike most early Monhegan photographers who were summer visitors, Triscott's decision to live year-round on the island enabled him to record its beauty in all seasons, especially winter.

Late nineteenth-century advances in photolithography made possible the widespread reproduction of photographs in newspapers, magazines, books, postcards, and advertising materials. In addition to the *New England Magazine* illustrations, Triscott sold a photograph of surf crashing against Swim Beach to G. W. Morris of Portland for a circa 1905 postcard. After the Island Inn opened in 1907, Triscott's photographs illustrated a promotional brochure for the new hotel.

A more significant source of income for Triscott was the sale

PHOTOGRAPH OF FISH HOUSES at Starling Cove, Monhegan Island.
COURTESY OF THE MAINE HISTORIC PRESERVATION COMMISSION

OVERPAINTED PHOTOGRAPH of fish houses at Starling Cove.
COURTESY OF THE MONHEGAN MUSEUM

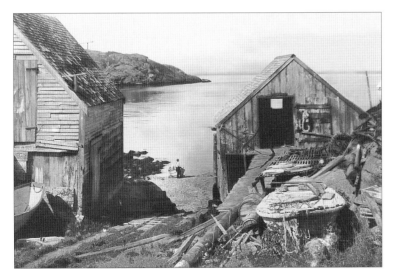
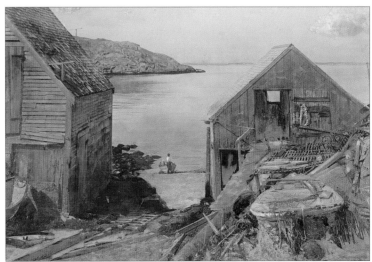

105

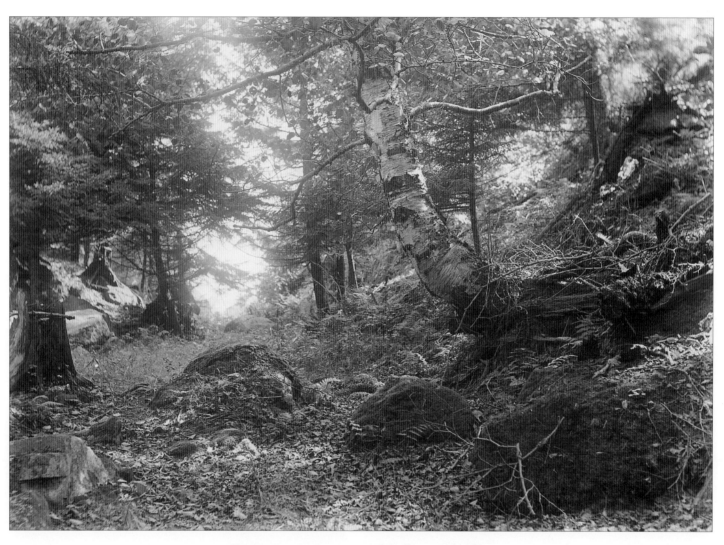

Photograph of woods, Monhegan Island.
Courtesy of the Maine Historic Preservation Commission

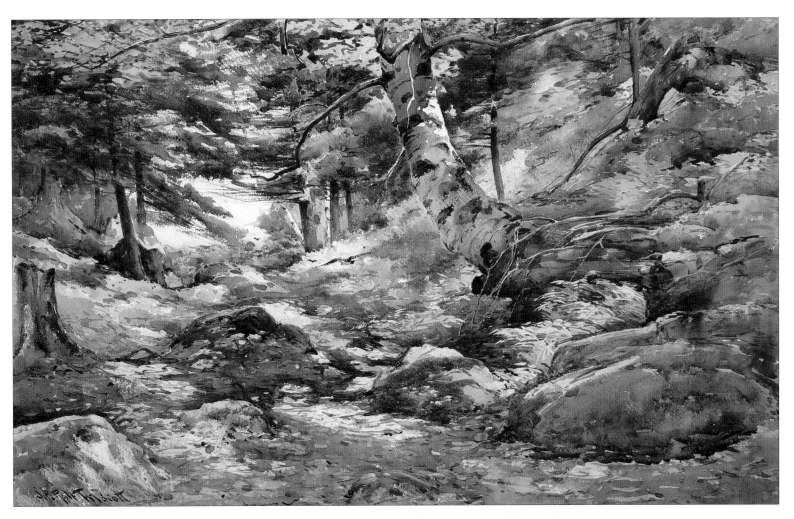

Woods, Monhegan Island. Watercolor on paper, 17³/4 x 27³/4.

of his photographs of Monhegan scenery as artworks. Like his watercolors, he sold his photographs in his studio to summer visitors seeking a souvenir of the island. One Philadelphia purchaser clearly treasured a Triscott surf photograph as a remembrance of a Monhegan vacation, having it richly framed at Strawbridge and Clothier and inscribing on the back, "Whitehead, Monhegan, Maine, June 17–July 21, 1913, Triscott Studio." Beginning in 1900, Triscott made 4½- by 6-inch contact prints from his 5- by 7-inch glass negatives and mounted them on 8- by 10-inch pieces of dark gray or black cardboard. On some of the negatives used for this format, he etched a copyright date and his signature "S. P. R. Triscott." Some of these 4½- by 6½-inch mounted photographs received light highlighting in watercolor, while others were so

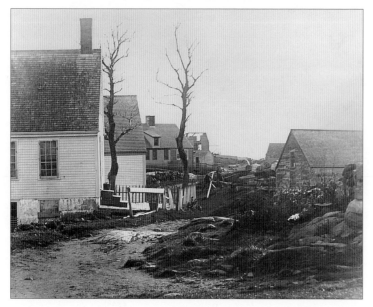

PHOTOGRAPH OF MONHEGAN VILLAGE.
COURTESY OF THE MAINE HISTORIC PRESERVATION COMMISSION

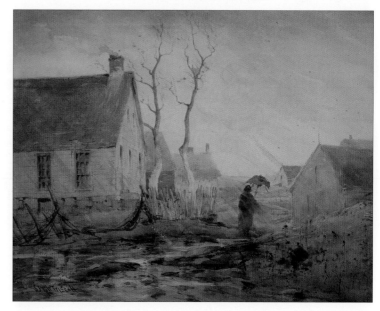

Stormy Day, Monhegan Village. Watercolor on paper, 16 x 20.
COURTESY OF SHEILA KOUGHAN

heavily overpainted as to make them virtually indistinguishable from actual watercolor paintings.

During the first two decades of the twentieth century, Samuel Triscott also made larger cliff and surf scenes which he printed in either sepia or gray tones, often with a gravure quality. Triscott's favorite subjects for these impressionistic art photographs included the Crow's Nest at Lobster Cove and a lone tree silhouetted against the headlands. Some of these photographs were printed as contact prints from 8- by 10-inch glass negatives, while others were enlarged to 9½ by 11¾ inches. Most of these prints were signed in ink by Triscott with a copyright date and his name.

Born seven years after the introduction of photography in 1839, Triscott lived in a world, both in England and America, in which the camera had assumed a growing presence. From the inception of the daguerreotype, artists had used photography as an

PHOTOGRAPH OF FISH HOUSES at Fish Beach, Monhegan Island.
COURTESY OF THE MAINE HISTORIC PRESERVATION COMMISSION

Manana Island—Monhegan Sunrise. Watercolor on paper, 22 x 36.
COURTESY OF DOROTHY MALONE

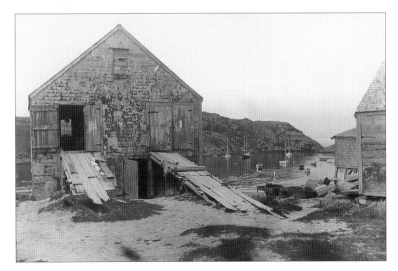

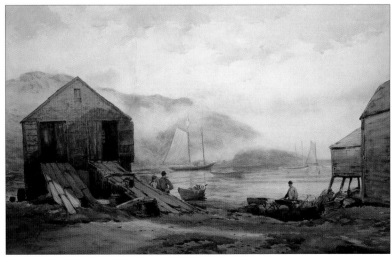

PHOTOGRAPH OF SEA SMOKE, Monhegan Harbor (above).
COURTESY OF THE MAINE HISTORIC PRESERVATION COMMISSION.
Sea Smoke, Monhegan Harbor (opposite). Watercolor on paper, $3^7/8$ x $8^3/8$.
COURTESY OF THE SOCIETY FOR THE PRESERVATION OF NEW ENGLAND ANTIQUITIES

alternative to sketching for recording subject matter for paintings. The development of the dry plate process in the 1880s made the camera an increasingly attractive tool for the artist to take into the field, and such Triscott contemporaries as Winslow Homer and Eric Hudson employed it in this way during the last two decades of the nineteenth century.

While many of Triscott's watercolors were painted on site, several of his pictures indicate a direct reliance on his photographs and were probably created in his studio with the aid of photographic prints. These include a woods scene at the Monhegan Museum, a small harbor scene owned by the Society for the

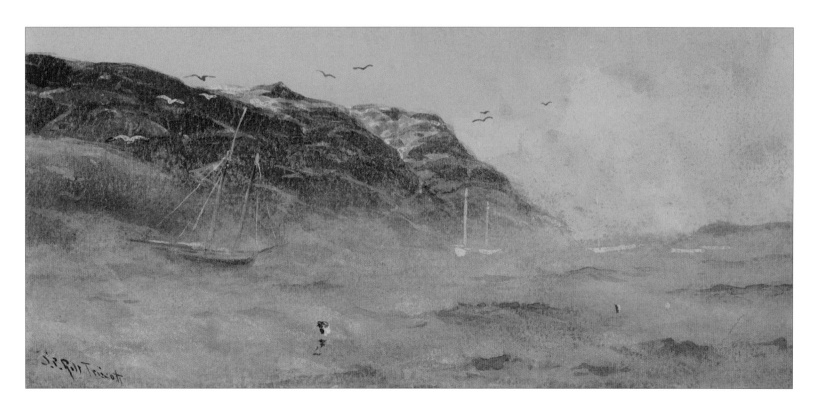

Preservation of New England Antiquities, and a major watercolor of Fish Beach, two of the village, and a gully scene, all in the Malone Collection. In the case of the Fish Beach scene and *Stormy Day*, which depicts the road through the village during inclement weather, the artist included figures to enliven the pictures.

Triscott's creation of watercolors based on photographs may help to explain the story of young Lelia Richards Libby spotting a new painting of White Head in the artist's studio when she knew he had not visited that location in years. Triscott explained this as a function of his mind's eye, saying "Ah, but I can still see the Headland." While surely Triscott had committed Monhegan's rugged topography to memory, his many photographs of island life and landscape must have provided him with a continuing source of inspiration and reference for his work. A century later, Triscott's photographs, many of them printed from his fragile glass negatives, form an important part of the artistic and documentary legacy which he left to Monhegan.

PHOTOGRAPH OF FIELD and woods (below), Monhegan Island.
OVERPAINTED PHOTOGRAPH of field and woods (right), Monhegan Island.
BOTH COURTESY OF THE MAINE HISTORIC PRESERVATION COMMISSION

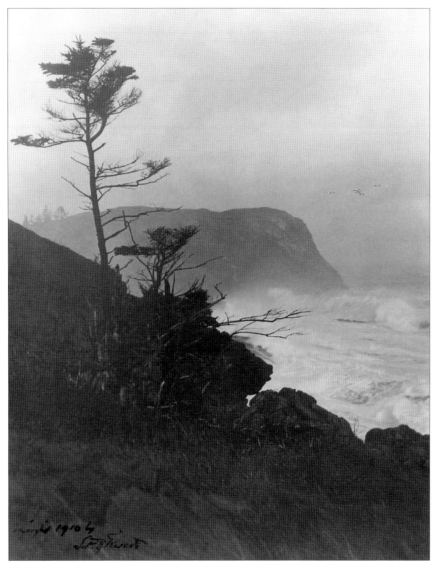

PHOTOGRAPH OF THE HEADLANDS, Monhegan Island, produced for
commercial sale, signed "Copyright 1910 by S. P. R. Triscott."
COURTESY OF THE MAINE HISTORIC PRESERVATION COMMISSION

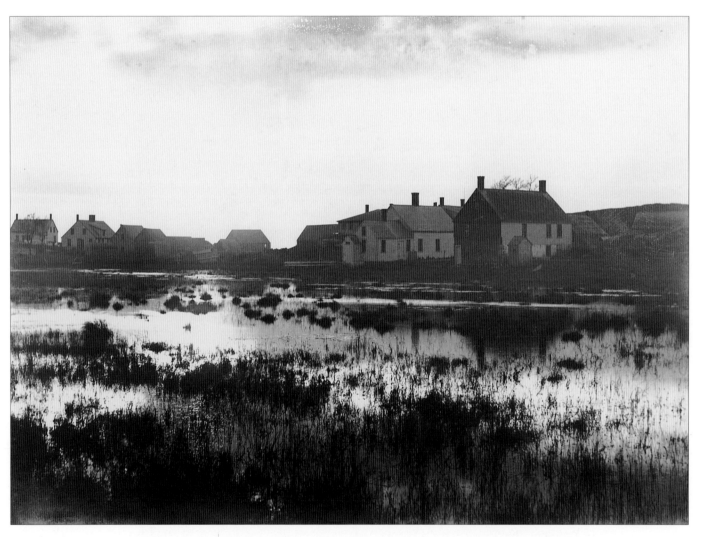

Photograph looking across the marsh toward the village, Monhegan Island.
Courtesy of the Maine Historic Preservation Commission

114

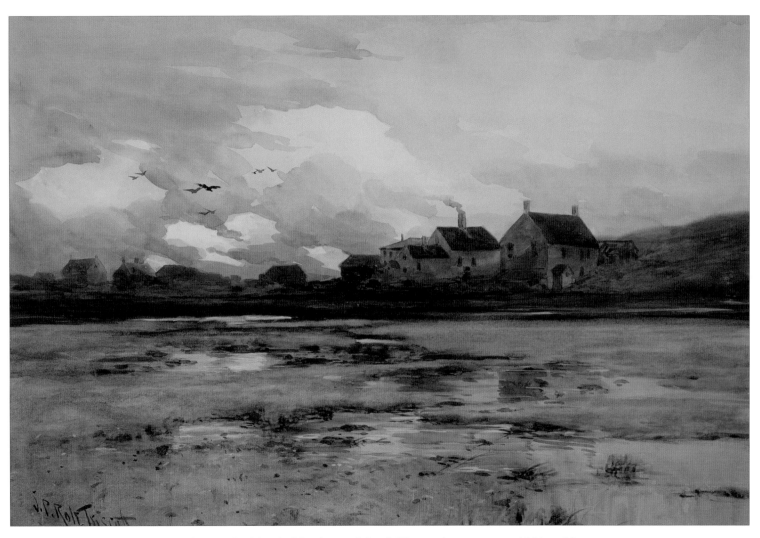

Across the Marsh, Monhegan Island. Watercolor on paper, 13 ¹/₄ x 20.
Courtesy of Dorothy Malone

THREE FIGURES STAND by a dory on Fish Beach silhouetted against Monhegan Harbor with Manana Island in the background. The man at the left forks fish from the dory into a "hand" or "drudge barrow." The "gundy," the roller glimpsed to the right of the center figure, was used when the long, many-hooked ground line was hauled back into the dory.

CENTERBOARD FISHING SLOOPS rest on Fish Beach in Monhegan Harbor. Possibly unique to Monhegan Island, this vessel type was built for the most part on the mainland at Round Pond.

FROM 1887 TO 1907, Captain William S. Humphrey sailed the packet schooner EFFORT between Boothbay Harbor and Monhegan Island, carrying passengers, mail, and freight. Seen here with sails reefed, the EFFORT approaches Monhegan Harbor in a westerly gale. As the *Lincoln County News* for September 1, 1892, noted, "The schooner that carries the mail from Monhegan to Boothbay made the passage Saturday in two hours, a distance of eighteen miles. The captain said it was blowing a regular gale."

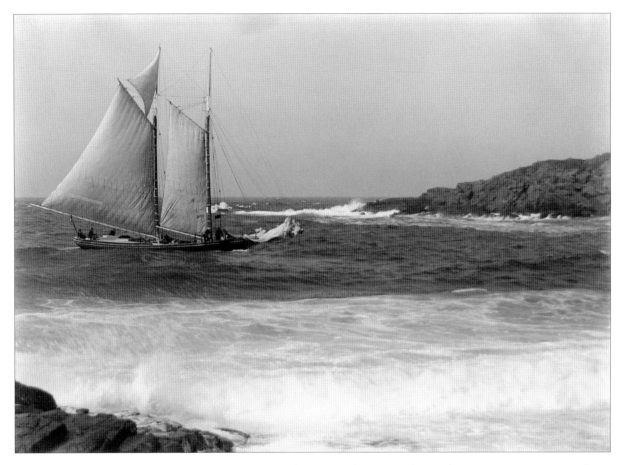

THE PACKET SCHOONER EFFORT sails into Monhegan Harbor, completing her customary passage from Boothbay Harbor. Built at Boston in 1854 as a Boston pilot schooner, the EFFORT was best known for her long service as the Monhegan packet under the command of islander Will Humphrey, who bought her in 1887. The *Boothbay Register* observed on June 23, 1888:

> Captain Humphrey left Monhegan Saturday, with the mail at twelve o'clock and at seven o'clock was back again, having delivered the mail, taken the Boothbay freight, and returned in this time. On Sunday he went off to Boothbay, landed passengers, and arrived back within five hours. Captain Humphrey has now a fast and fine sailing yacht.

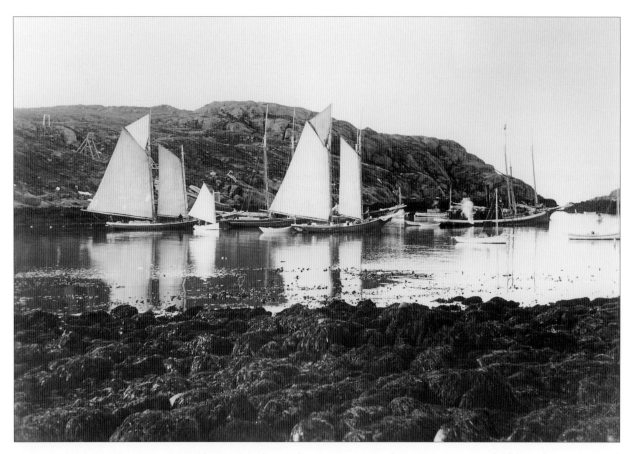

THIS PHOTOGRAPH DEPICTS Monhegan Harbor in late winter or early spring. Two yacht-like schooner-rigged lobster smacks, with their sails set, lie at anchor, while at the right, exhausting steam, is a steam smack. The smacks, equipped with flooded "wet wells" in their holds, have come to buy lobsters for Portland dealers. On March 5, 1891, the *Lincoln County News* asked, "'What makes the lobsters so scarce?' 'Where have they gone?' Echo softly answers: 'To Portland in smacks.'"

FISHERMEN STAND ON Fish Beach looking at Monhegan Harbor with their dories moored nearby. Two of the dories at the right are loaded with a seine for catching herring or mackerel. The sloop under sail is probably a visiting yacht. Of these working and pleasure boats, the *Lincoln County News* commented in 1891:

> One night last week, six of our fishermen in their dories took a row around the Island looking for herring and when off Black Head all entered in a race for home, but it being so dark it was impossible to tell which got there first. June 18, 1891.
>
> Quite a number of yachts visited this place last week. We should judge that some of the parties were from some part of the world that had never been civilized by the way they behaved. Such people should be dealt with by the law and a double-barreled gun. August 27, 1891.

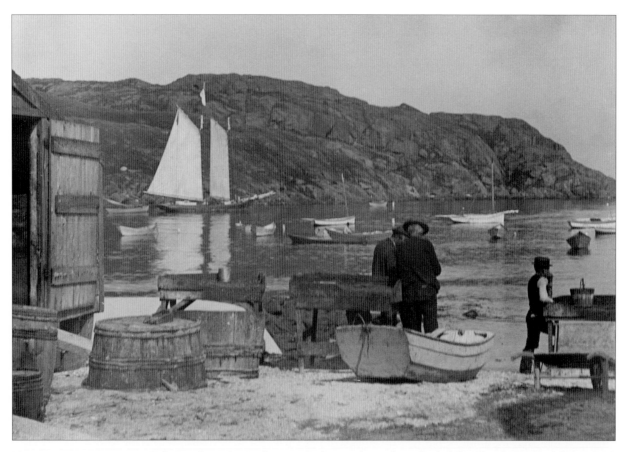

THIS PHOTOGRAPH OF Fish Beach and Monhegan Harbor is framed at the left by the doorway of the shed which once fronted the Henry Trefethren Fish House (1784, now "The Eider Duck" cottage). The packet schooner EFFORT lies at her mooring in the harbor with foresail and mainsail set. On the beach two splitting tables and rinsing butts stand ready for the work of fish processing. The island-built punt or skiff is likely one of the "Davis patent skiffs" mentioned in period newspaper articles. Many of these burdensome little craft, whatever their proper name, were purchased by visiting yachtsmen. As the *Pemaquid Messenger* reported on January 26, 1893, "Mr. C. P. Wincapaw has taken contracts to build quite a number of Davis's patent skiffs."

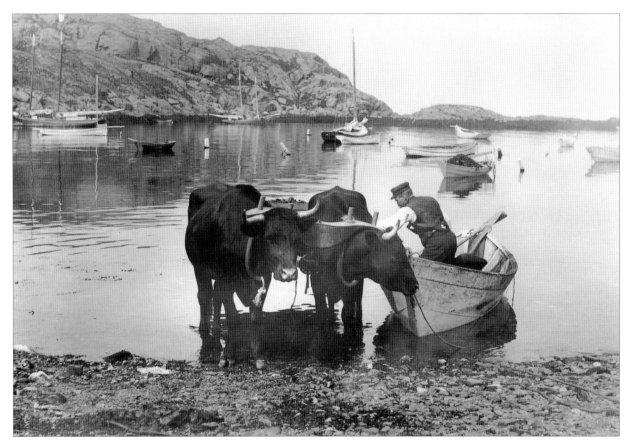

Triscott's camera captured this Fish Beach scene of coal being transferred from dory to ox cart for delivery on the island. The coal, presumably for stoves, probably arrived aboard the Effort or a Portland fish dealer's schooner which had come to load dried fish. The steers are "red ruby" Devons, an ancient English breed once popular in New England. Such animals required their owner's attention, as reflected in the following report from the *Pemaquid Messenger* on May 21, 1891: "F. F. Humphrey's steers started across the harbor the other day with the cart, but were stopped by a man in a skiff."

TWO LOCAL LANDMARKS stand side by side on Fish Beach, the Henry Trefethren Fish House and Trefethren's "Dry Fish House," which was washed out to sea in 1978. On the beach, traps are being loaded into dories, probably at the beginning of the lobster fishing season in December. Traps were island-built of spruce bows and common laths. The appearance in island waters of thousands of laths, once the deckload of a wave-washed lumber schooner, was an occasion of great rejoicing. Dories too old to be watertight were decked over, bored full of holes, and moored in the harbor for use as lobster "cars" or holding pens.

On November 5, 1891, the *Pemaquid Messenger* wrote of the coming season:

The fishermen are busy getting ready for lobstering…. The people are awakened each morning by the sound of the hammer which continues until the shades of night blind the lobster catcher's eye. Then he hies himself away to his home and bed to dream of fish wardens and the cull he is going to get when he takes his car alongside the smack.

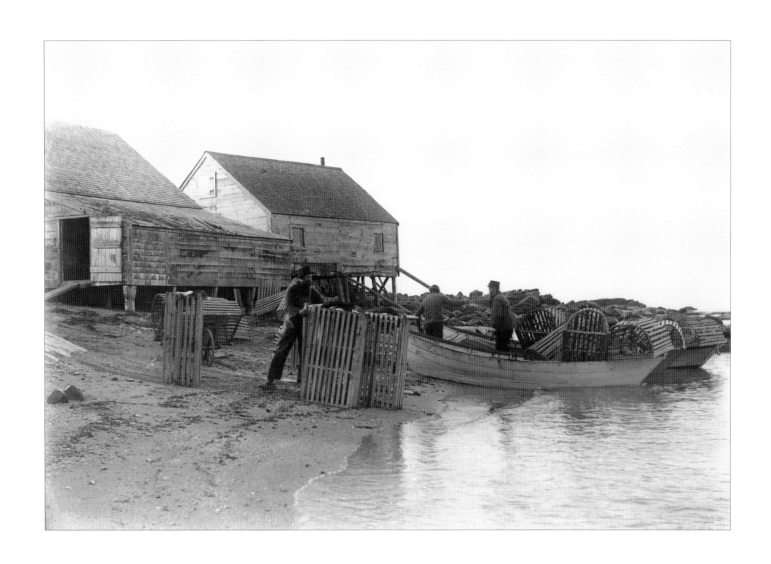

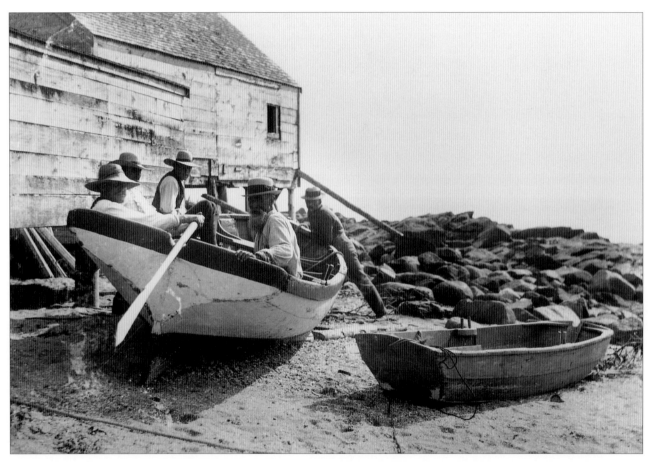

LIKE HIS FELLOW ARTIST Eric Hudson, Triscott probably posed the local fishermen in this photograph to use as an idea for a future painting. The scene is Fish Beach, with the Henry Trefethren Fish House and Trefethren's "Dry Fish House" in the background. The boat being navigated on an imaginary sea may once have been a ship's boat. An island-built punt, or skiff, is at the right.

CLAUDIN WINCHENBACH (Wincapaw) pulls a skiff used to ferry him from Fish Beach to his sloop or dory moored in the harbor. Behind him are lobster traps and nets hung over poles to dry.

IN THE FOREGROUND rests an early gasoline-powered fishing boat, somewhat similar to the long-bowed "power dory" commonly used in the early 1900s. The weatherbeaten structure is the Thomas Horn Fish House (1781), which has stood on Fish Beach for more than two centuries.

THE VICINITY OF FISH BEACH was a favorite gathering place for the men and boys of the village to talk while waiting to put out to sea in quest of fish. This group is assembled in front of the Horn Fish House.

THESE FOUR ISLANDERS pose for the camera with a large seineboat which has been hauled to a safe location adjacent to Fish Beach. Such seine boats were intended to be rowed around schools of mackerel while the long purse seine was payed out astern. This particular boat may have been the one allowed to decay ashore as a result of a feud between the owners. In the background are the Trefethren Fish House, the Horn Fish House, and George Trefethren's Fish House (c. 1825, "The Black Duck").

THE STRAIGHTFORWARD LINES and shingled exteriors of Monhegan's working-waterfront architecture are reflected in the William Studley Fish House (c. 1845) on Fish Beach. This large vernacular structure was replaced by Frank Pierce in 1930 with a smaller fish house on the same site.

THIS PHOTOGRAPH OF Swim Beach from the landing reveals a line of three storm-battered buildings, the most prominent of which is the Josiah Starling Fish House with its large shed extending from the front. A corner of the Henry Trefethren House (1784, "The Red House") can be seen at the far right.

MANANA ISLAND AND MONHEGAN HARBOR provide the backdrop for this view of the village. From left to right, buildings shown include the Horn House (1781, burned in 1963), the Horn Fish House, Thomas Marshall's barn, the Studley Fish House, the Thomas Marshall House (1843), "The Influence" with Hiram West's barn in the foreground (c. 1870, now "The Notice Shed"), and "The Red House." Vessels in the harbor swing between tide and wind, while a nor'west gale blows outside. In no other wind is the harbor so secure.

TWO VILLAGE LANDMARKS that remain to this day are the Trefethren houses. A fisherman and farmer, Henry Trefethren built the cape at the right in 1784, now known as "The Red House." Its Greek Revival lines indicate a mid nineteenth-century remodeling. More than four decades later in 1826, he also erected Monhegan's most imposing house, "The Influence." In this two-family Federal-style dwelling, Henry occupied the west side facing the harbor until his death in 1838, while his son George lived on the east side.

REFLECTING MONHEGAN'S DEVELOPMENT as an artists' colony at the end of the nineteenth century, William Claus and Alice Swett purchased the east side of "The Influence" in 1899. Claus was a Boston portrait painter, while Swett was an accomplished watercolorist who taught art at Allston High School in Boston. Claus and Swett used "The Influence" as their base for summers of painting on Monhegan, and they furnished it with antiques. The exterior was enhanced by an ivy-shrouded doorway and an old-fashioned New England dooryard garden.

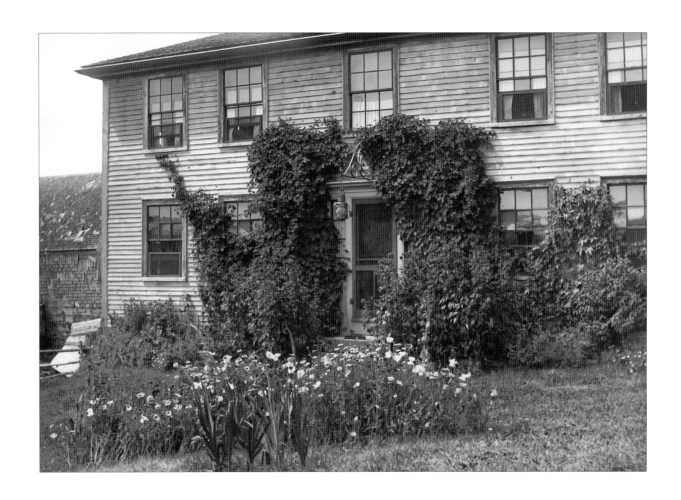

THIS CLOSE-UP VIEW OF the doorway of "The Influence" underscores the charming effect created by William Claus and Alice Swett's entrance plantings. The large brass lantern hanging from the ornamental iron bracket came from the famous coastal steamer DANIEL WEBSTER.

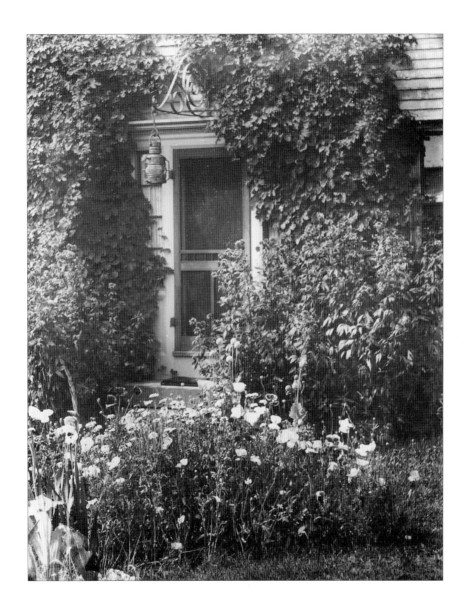

LOOKING ACROSS THE VILLAGE, Triscott created this panoramic photograph, which includes the Albee House hotel (now the New Monhegan House) at the left and the George Trefethren House (1822) and the Josiah Starling, Sr. House (1784) in the center. Above these two houses stand the Josiah Starling, Jr. House (1816, "The Pink House," now incorporated into the Island Inn), the John Sterling House (1809), the Moses Starling House (1847), the William Starling Store, and the Joseph Starling House (c. 1822, "The Swallow's Nest"). The barn at the lower right may have been used to build the Novelty Apartments now on the site.

LOOKING NORTHWARD through the village, from left to right, are the Trefethren and Starling Barns, Claudin Winchenbach's house (1879), Joseph Lermond's house (1873, "Shining Sails"), the original Monhegan House, Josiah Starling, Sr.'s house, and George Trefethren's cape.

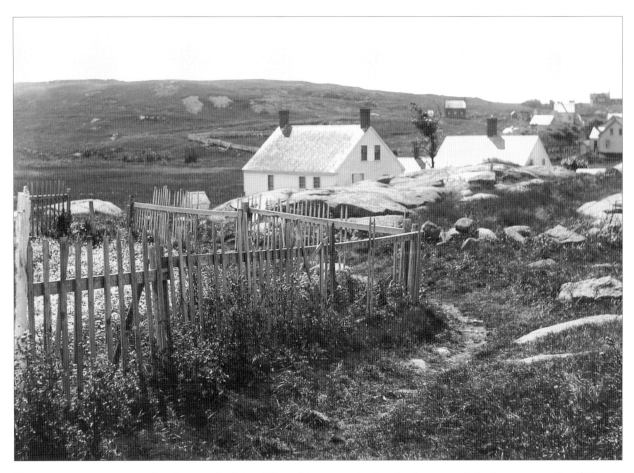

TAKEN FROM BEHIND what is now the Island Inn, this dramatic view looks toward the barren terrain of Horn's Hill, kept open by grazing sheep. The chimneyed rooftops in the center of the photograph belong to the Josiah Starling, Sr. House and the George Trefethren House, which still stand on the road through the village.

THE MAN WITH HIS PAIR OF steers and an ox cart seen loading coal at Fish Beach reappears on an otherwise empty road through the village. Prominent landmarks in this photograph are the Josiah Starling, Sr. House at the left, the Starling Barn in the center, and Claudin Winchenbach's house at the right.

THIS VIEW OF THE north end of the village includes the Starling Barn, the rooftop and chimney of the Josiah Starling, Jr. House, the Moses Starling House, the Claudin Winchenbach House, and the John Sterling House.

MANANA LOOMS in the background of this north-end village photograph, at the center of which are the Zebulon Simmons House (c. 1855), the Josiah Starling, Jr. House, the Moses Starling House, the Claudin Winchenbach House, and the John Sterling House. The road to Lighthouse Hill appears in the foreground.

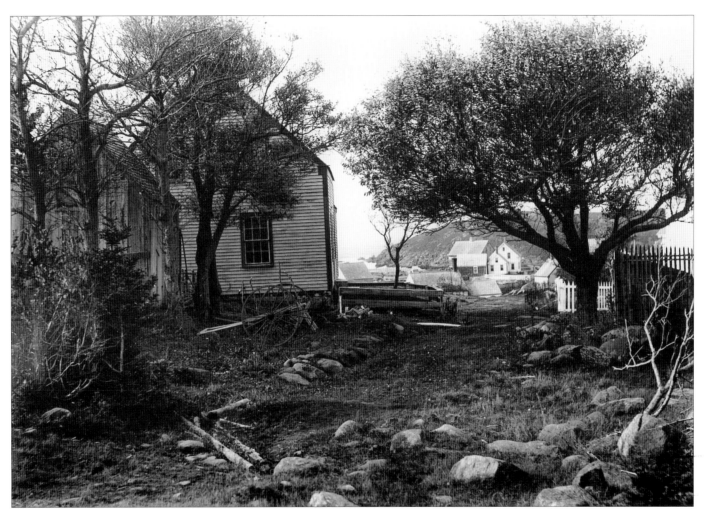

OVERLOOKING THE NORTH END of the village is the Reuben Davis House (1875) with a magnificent tree in the yard. Davis was a fisherman whose fish house, known as "The Wik-Wak," was the subject of Triscott watercolors.

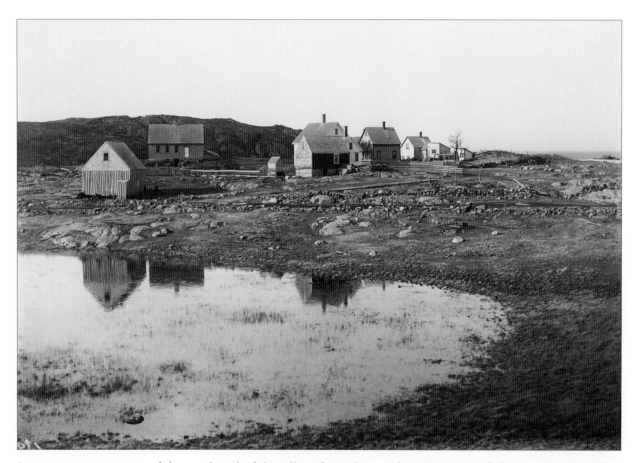

IN THIS PHOTOGRAPH of the north end of the village from the meadow, Triscott artfully captures the reflections of three buildings in a pool of water. Seen from the rear are the Starling Barn, the Josiah Starling, Jr. House, the Moses Starling House, the John Sterling House, and the Thomas Brooks House (c. 1821, incorporated into the Oram Cottage).

KNOWN AS "THE SWALLOW'S NEST," the Joseph Starling House was built about 1822 in the field between the road to the landing and the Jenney cottages. Triscott's dramatic photograph records the demolition of this central-chimneyed Cape and was probably taken between 1905 and 1910, at the same time that Rockwell Kent made a similar drawing of the demise of this island landmark.

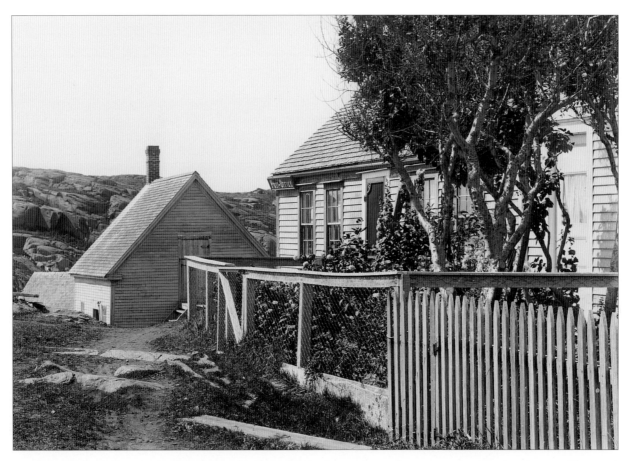

THE ROCKY PATH to the landing passes by the John Sterling House, then in use as the island post office, and heads towards Sterling's Cistern House ("Uncle Henry's"). To the left below is the roof of John Starling's fish house (c. 1809, now "The Barnacle"). A chicken-wire fence protects the dooryard garden of the Sterling House from wandering animals.

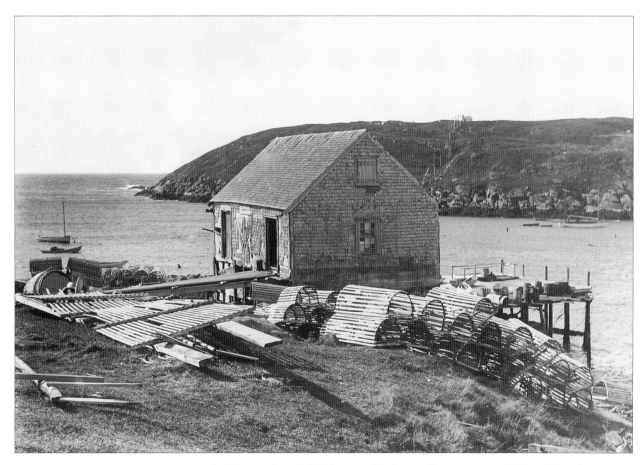

ADJACENT TO THE LANDING stands the weathered fish house of John Starling, surrounded by flakes for drying fish and piles of lobster traps. In the twentieth century the building housed tearooms and gift shops, most recently "The Barnacle." In the background the tramway used to supply the fog station on Manana climbs the steep, rocky slopes of the island.

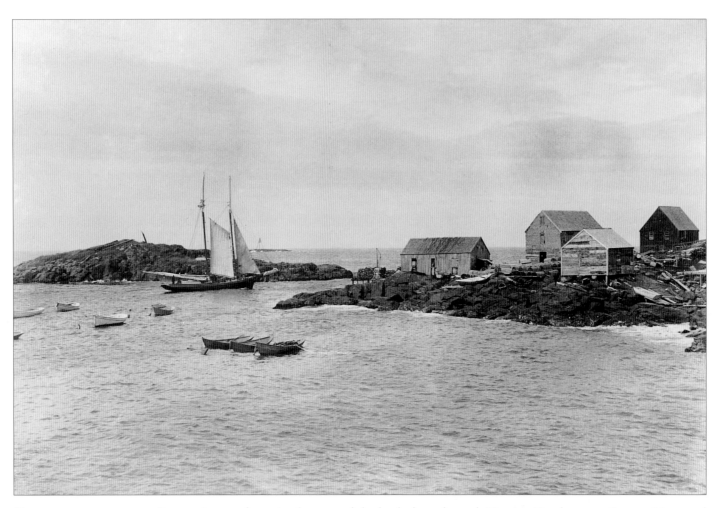

THE PACKET SCHOONER EFFORT is seen departing by way of the back door through Herring Gut between Smutty Nose and Monhegan. On the island landing are the freight shed, the John Starling Fish House ("The Barnacle"), another Starling Fish House, and the Davis Fish House, which was washed out to sea in a winter storm.

A FISH SPLITTING TABLE, with a large rinsing butt at the right, stands on a small wharf in front of "The Wik-Wak," Reuben Davis's fish house near Starling Cove.

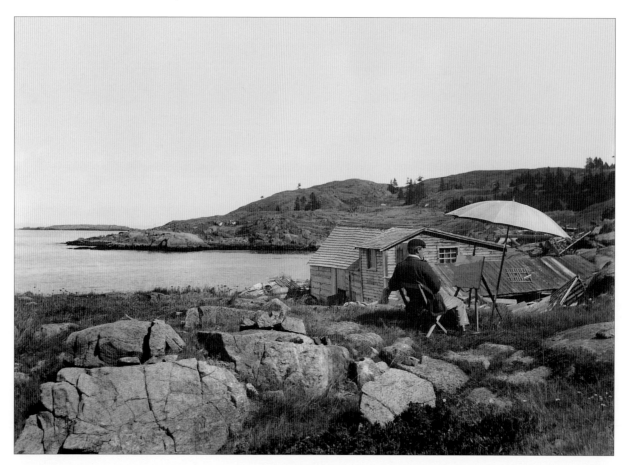

LOOKING ACROSS DEADMAN'S COVE to Calves Cove, Triscott captured this tranquil scene of a fellow artist seated on a folding chair in front of his easel with an umbrella for protection from the sun. Behind this dapperly dressed unknown painter is "The Hermitage," a rambling fishing shack belonging to Harrison Humphrey, which served as the subject for a major Triscott watercolor (see page 79).

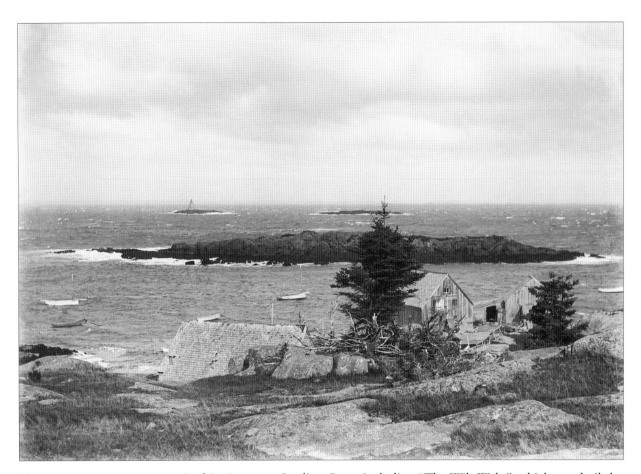

THREE FISH HOUSES appear in this view near Starling Cove, including "The Wik-Wak," which was built by Reuben Davis in the 1880s. These structures are sheltered from a nor'west gale by the large rock known as Nigh Duck. Western Duck, with its beacon, and Middle Duck lie beyond.

THIS PHOTOGRAPH masterfully depicts mackerel seining at Seal Ledges during the summer. The two schooners are yacht-like clipper mackerel seiners, probably from Gloucester, Massachusetts. The schooner at the right is towing her white seineboat astern. The seineboat belonging to the other vessel is seen to the far right, having cast off to try to surround a school with her purse seine. Islanders fish from dories. The sea is flat, but swells worry the breaking ledges.

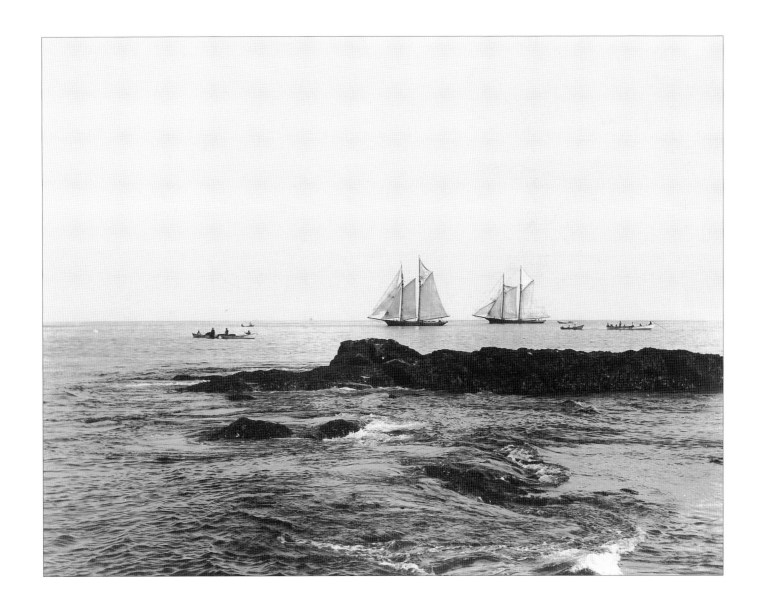

THIS PHOTOGRAPH OF LIGHTHOUSE HILL was taken from the village looking across the meadow with the reflection of the Keeper's House, Monhegan Light, and the Assistant Keeper's House in the water. The federal government acquired this site on "Lookout Hill" in 1822 and built the first lighthouse and keeper's dwelling there the following year. The Keeper's House seen here at the left dates from 1875 and became the Monhegan Museum in 1962. The handsome granite block light tower was built in 1850 from designs by the Boston architect Alexander Parris to replace the earlier stone one. At the right is the Assistant Keeper's House of 1857, which was demolished in the 1930s and replicated on the exterior in 1997–98 to serve as the art gallery and office for the museum.

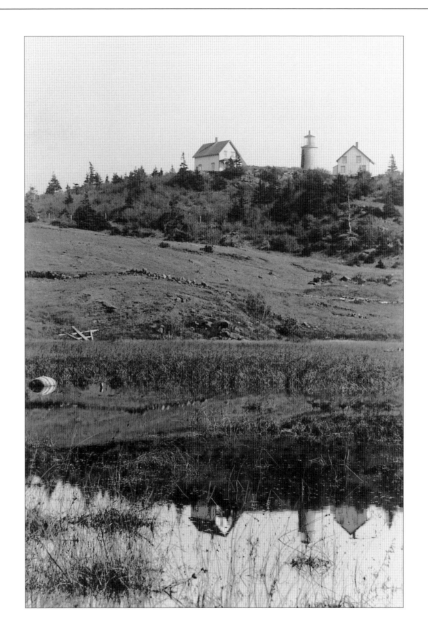

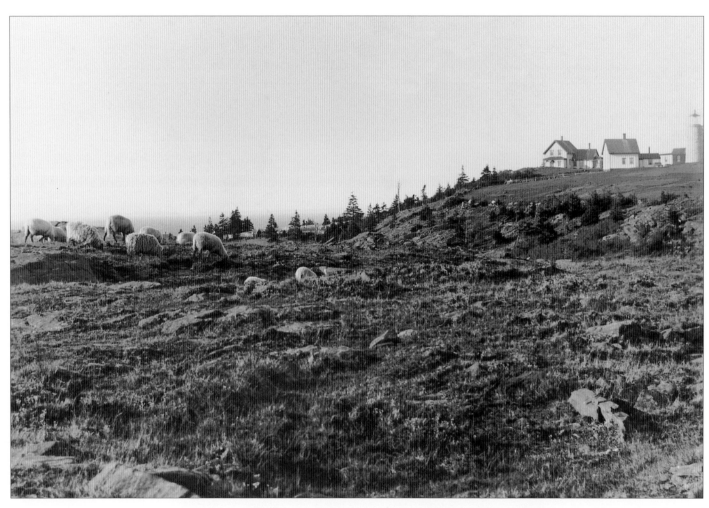

SHEEP GRAZE ON CAMERON'S KNOLL in this view looking from Horn's Hill to Lighthouse Hill. Atop Lighthouse Hill stand the Keeper's House and the catwalk which connects it to Monhegan Light with the Assistant Keeper's House in the foreground.

MUCH OF MONHEGAN'S rugged topography proved inhospitable for grazing cattle, but this small herd seems at home in a field below Horn's Hill. These are free-ranging cattle, fenced out rather than fenced-in. The hazards of this approach are reflected in the following comment by the *Lincoln County News* on March 11, 1887: "Mr. Edmund Stevens' cow accidently tumbled over a high stone wall, and but for the timely aid of Mr. F. F. Humphrey would have died in a few minutes."

LIKE CATTLE, SHEEP grazed freely on Monhegan in the nineteenth century. Triscott often included sheep in his watercolors, so it is not surprising to find him photographing a group of these animals penned for shearing. Herding the sheep from around the island for the annual ritual of wool gathering was a challenging task, as Ed Brackett found out. On June 13, 1889, the *Lincoln County News* reported that, "Ed Brackett met with a very painful accident Friday. He was chasing sheep to be sheared and missed his footing and fell over a steep bank, injuring his right knee quite severely."

THIS GLORIOUSLY EVOCATIVE PHOTOGRAPH captures a sparkling moment as sunlight bathes the ocean waters, and two mackerel schooners, with seineboats towing astern and lookouts aloft, stand off in search of a school to set on.

164

IN THIS DRAMATIC PHOTOGRAPH waves crash on the remains of the schooner E. M. SAWYER of New Bedford, Massachusetts, which was wrecked on the southern end of Monhegan about 1904. The SAWYER was built at Jonesport, Maine, in 1869, and for most of her life sailed out of Machias. She last appeared in the 1904 edition of the *List of Merchant Vessels*.

THE WRECK OF THE SCHOONER JOHN SOMES of Calais, Maine, lies on the rocks of Lobster Cove at the southern end of Monhegan about 1896. Built at Mount Desert in 1868, the SOMES last appeared in the *List of Merchant Vessels* in 1896. Most of the vessel casualties at Monhegan were small coasting schooners, with many hailing from New Brunswick. Across the harbor entrance, the horn tower of the government fog station rises above the rocky island of Manana. On August 21, 1909, the *Boothbay Register* observed that the Manana fog signal was "very baffling at times, however, for some atmospheric reason, and cannot be depended upon. One night it may be heard within a radius of miles and the next may be entirely muffled."

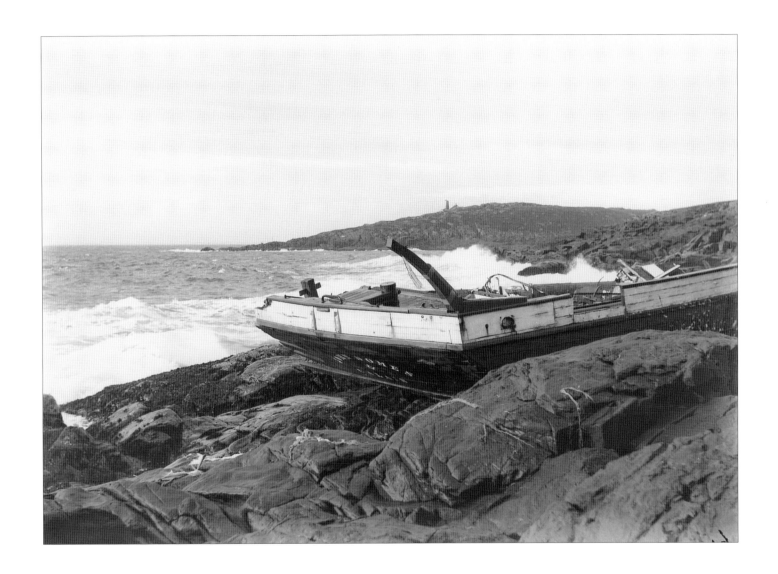

Triscott's camera catches the exact moment of surf crashing on "The Washerwoman," a rocky ledge at the southern tip of Monhegan, while the sun highlights the turbulent ocean water in the foreground as it breaks on the shore.

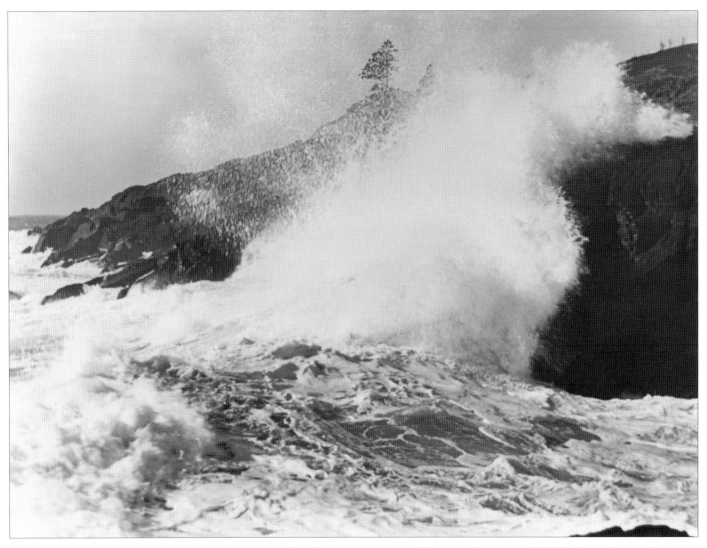

RISING FROM A CHURNING SEA, surf pounds against the rocks between Christmas Cove and Gull Rock at the southern end of the island. Silhouetted high in the background is the weathered pine on "The Crow's Nest," an island landmark familiar to passing mariners.

THE RUGGED BEAUTY of the southern end of Monhegan is expressed in this closeup photograph of "The Crow's Nest," a barren ledge with its brave outcropping of storm racked pines.

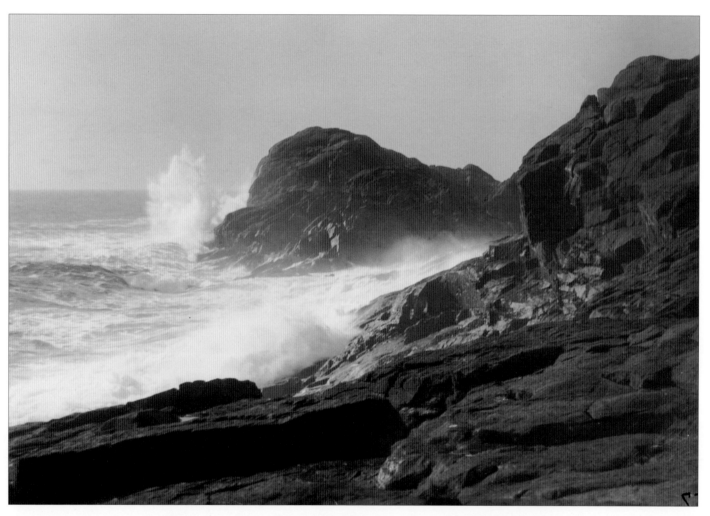

LOCATED BETWEEN Christmas Cove and Burnt Head, Gull Rock juts out into the ocean like a miniature headland. Often battered by crashing surf, enshrouded in misty fog, and circled by crying gulls, the rock was a favorite subject for Triscott's watercolors. Here the artist photographed Gull Rock from under Burnt Head on a clear, bright day.

KNOWN AS "BOAR'S HEAD," this remarkable rock formation projects from the shoreline below Burnt Head, displaying an uncanny resemblance to a giant pig.

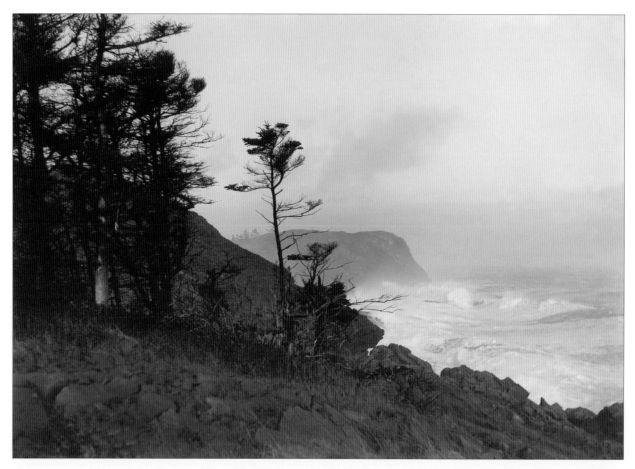

WAVES BREAK AGAINST Monhegan's outer coastline in this highly pictorial 1910 photograph of the headlands from Burnt Head. The desolate beauty of the scene is heightened by the silhouetted effect of the dark foreground with its starkly weathered trees. Triscott's fondness for this view is reflected in several watercolors as well as in photographs that he produced for commercial sale.

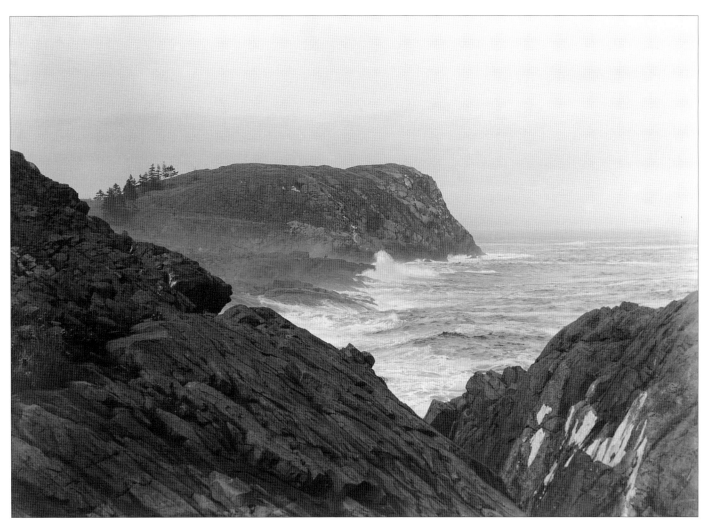

THE HEADLANDS RISE majestically from the sea in this view from Gull Rock.

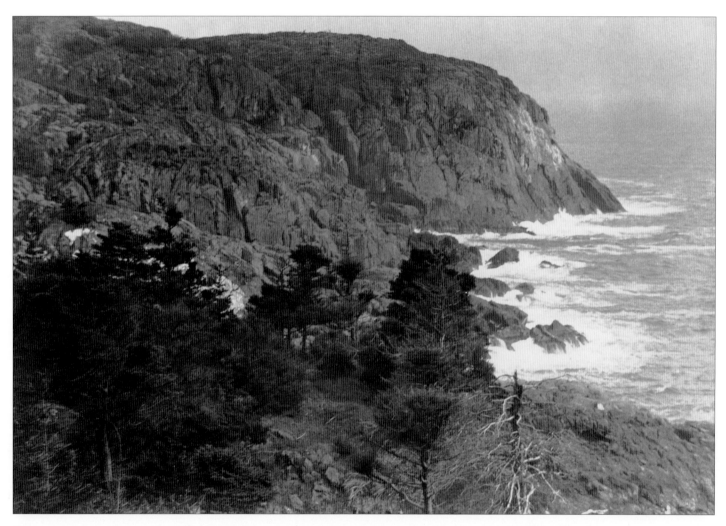

THE POWERFUL PRESENCE of Black Head is conveyed in this photograph taken from Little White Head.

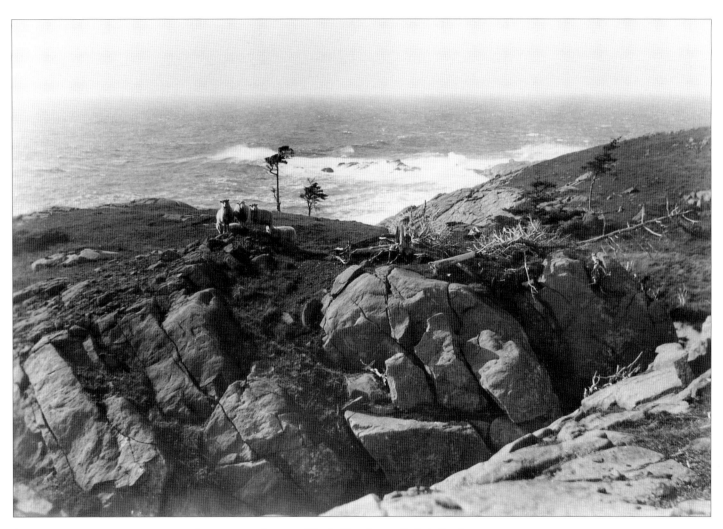

SHEEP GRAZE ON THE ROUGH, barren terrain atop Black Head near Pulpit Rock.

THE ATMOSPHERIC QUALITIES of sea smoke rising from Monhegan Harbor fascinated Triscott, who recreated its vaporous appearance in several watercolors. The artist took this photograph of the harbor with a snow-covered Manana in the background on a bitterly cold day. The schooners, with their topsides and shrouds encased in ice, appear to be lobster smacks. Of such weather conditions, the *Pemaquid Messenger* wrote on December 10, 1895:

> Capt. E. Burns in Smack EDITH THOMPSON called here Saturday and bought 1,500 lobsters at 12 cents a piece. A cold wave from the north struck this place Tuesday night continuing most of the week with frequent dashes of snow, which dipped the thermometer to four above zero. The catch of lobsters this week has been light owing to the bad weather, as the fishermen are unable to get their traps in position. Capt. Warren Morse and son arrived here Tuesday with a cargo of pressed hay and are waiting for a chance to make their escape to the north shore.

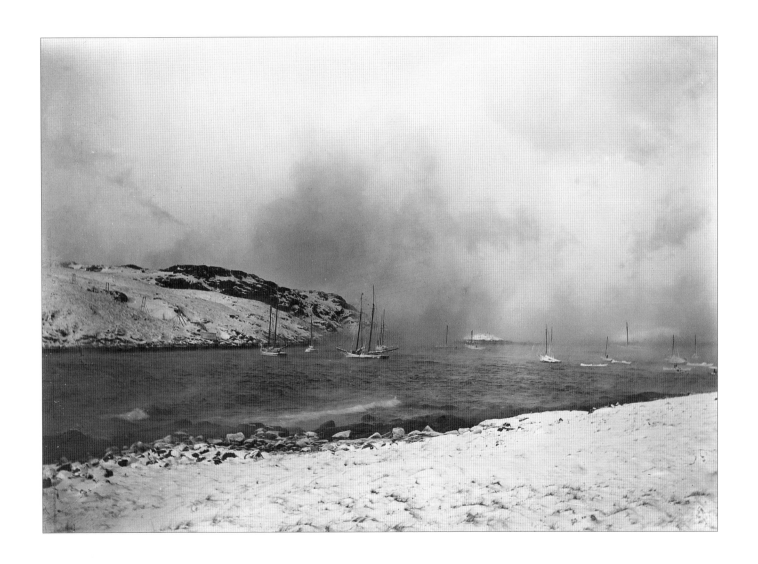

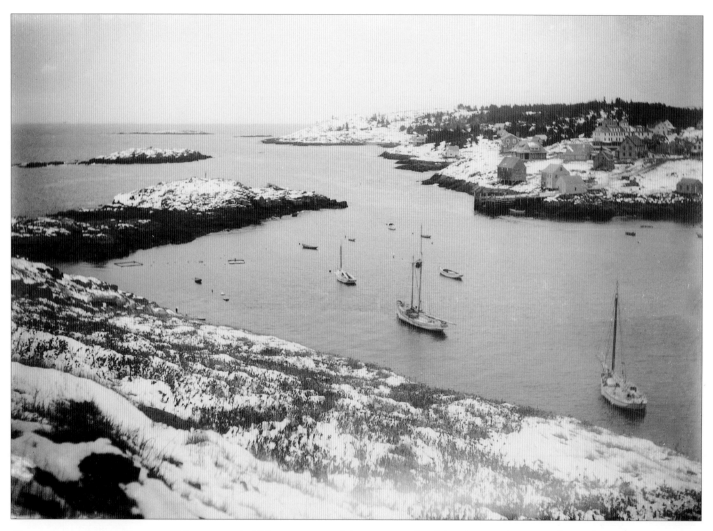

ON A GRAY WINTER'S DAY, Triscott carried his camera up Manana to take this panoramic view of Monhegan Harbor with Smutty Nose and the landing on either side of Herring Gut. Nigh Duck lies beyond.

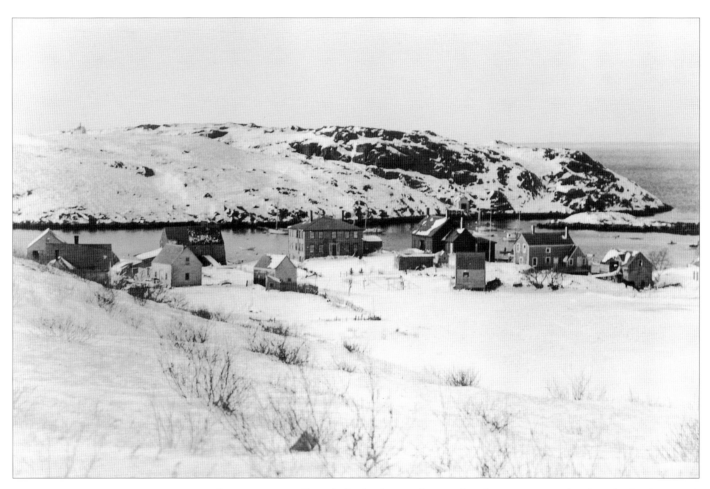

A SNOW-COVERED VILLAGE is seen from Horn's Hill with the harbor and a nearly white Manana Island in the background. At the center of the photograph stands "The Influence" with "The Red House" to the right.

TRISCOTT MOVED HIS CAMERA further to the right of the previous photograph for this view of the village in winter from Horn's Hill. In doing so, he included "The Pink House" at the far right (now incorporated into the Island Inn) and, from right to left, the Josiah Starling, Sr. House and the George Trefethren House.

TAKEN FROM HORN'S HILL, this photograph depicts the village in the depths of winter. Rooftops and trees are embedded in heavy snow. Recognizable landmarks include the George Trefethren and Josiah Starling, Sr. Houses at center left and above them "The Pink House," the John Sterling House, the Moses Starling House, and "The Swallow's Nest."

GRACEFUL CHERRY TREES along the village road opposite "The Influence" line the center of this striking winter photograph of Lighthouse Hill with its Keeper's House, Assistant Keeper's House, and Monhegan Light.

A LONE WEATHERED TREE provides the foreground for this photograph of snow-covered rocks in the Gull Rock area of the island.

THIS SENSITIVELY COMPOSED PHOTOGRAPH of a snow-covered "Crow's Nest" relates to several beautifully executed Triscott watercolors of Monhegan in winter.

Chronology
by Richard H. Malone

1846 Born in Gosport, England, January 4

1871 Age 25—Arrive New York, New York, March 9 on S. S. CHINA with Mr. and Mrs. George A. Wheeler

1872 Age 26—Location unknown—probably Worcester, Massachusetts

1873 Age 27—Worcester; Wheeler & Triscott, Civil Engineers, 379 Main Street

1874 Age 28—Worcester; Fall, New Hampshire
Exhibited:
Boston, 12th Massachusetts Charitable Mechanics Association, 1 w/c

1875 Age 29—Worcester; listed as artist and civil engineer. Wheeler not listed

1876 Age 30—Worcester

1877 Age 31—Worcester

1878 Age 32—Worcester; Judge of Awards, Worcester County Charitable Mechanics Association Drawing School

1879 Age 33—Boston; listed as civil engineer, 2 Harvard Place

1880 Age 34—Location unknown, not listed in *Directory*, Boston or Worcester
Exhibited:
Boston, 21st Boston Art Club, 2 w/c
 22nd Boston Art Club, 1 w/c
Worcester, Worcester Art Society, 2 w/c

1881 Age 35—Boston; listed as artist, 81 Milk Street; summer, Saguenay River, Canada, Woods Hole, Massachusetts
Exhibited:
Boston, 23rd Boston Art Club, 2 w/c
 Boston Art Club, 6 w/c
 Boston Art Club, one-man show, 156 w/c, 15 b&w

1882 Age 36—Boston; listed as artist, 433 Washington Street (Century Building)
Exhibited:
Boston, Curtis Sale
 26th Boston Art Club, 3 w/c, 1 b&w
 Pelham Studio, one-man show, many w/c

1883 Age 37—Boston; listed as artist, separate listing as art teacher; summer, Arichat, Cape Breton Island
Exhibited:
Boston, 27th Boston Art Club, 1 oil
 Museum of Fine Arts, Fourth Annual, w/c
 Boston Art Club, informal exhibit monthly display, March 16, w/c
 28th Boston Art Club, 3 w/c
 Boston Art Club, informal exhibit monthly display, November, w/c
 Chase's Gallery, one-man show, 35 w/c

1884 Age 38—Boston; summer, Kennebunkport, Maine, Mount Monadnock, New Hampshire
Exhibited:
Boston, 29th Boston Art Club, 1 oil
 30th Boston Art Club, 4 w/c, 2 b&w
 15th Massachusetts Charitable Mechanic Association, 2 w/c
 Century Building, "a large number of" w/c
New York, 17th American Watercolor Society, 4 w/c

1885 Age 39—Boston; summer, Kennebunkport, Maine; signed works "S. P. Rolt Triscott"
Exhibited:
Boston, 31st Boston Art Club, 1 oil
Chase's Gallery, one-man show, 16 w/c
32nd Boston Art Club, 3 w/c, on jury
1st Boston Society of Water Color Painters, 6 w/c
New York, 18th American Watercolor Society, 4 w/c

1886 Age 40—Boston; summer, Turbats Creek (Kennebunkport) and Ogunquit, Maine
Exhibited:
Boston, Chase's Gallery, one-man show, 40 w/c
34th Boston Art Club, 3 w/c, on jury
New York, 19th American Watercolor Society, 4 w/c

1887 Age 41—Boston; summer, Annisquam, Massachusetts, Ogunquit, Maine
Exhibited:
Boston, Paint and Clay Club, 6 w/c
2nd Boston Society of Water Color Painters, 3 w/c
Chase's Gallery, one-man show, 50 w/c
36th Boston Art Club, 3 w/c, on jury
New York, 20th American Watercolor Society, 1 w/c

1888 Age 42—Boston; summer, England
Exhibited:
Boston, Paint and Clay Club, 4 w/c
3rd Boston Society ot Water Color Painters, 3 w/c
Boston Art Club, 3 w/c
4th Boston Society of Water Color Painters, 4 w/c
Chase's Gallery, 3 w/c
New York, 21st American Watercolor Society, 2 w/c

1889 Age 43—Boston; summer, Wellfleet, Massachusetts
Exhibited:
Boston, Chase's Gallery, one-man show, 30 w/c
New York, 22nd American Watercolor Society, 2 w/c

Chicago, The Art Institute of Chicago, Water Color Exhibition, 1889, 1 w/c

1890 Age 44—Boston; summer, Ogunquit and Cutler, Maine
Exhibited:
Boston, 5th Boston Society of Water Color Painters, 3 w/c
42nd Boston Art Club, 3 w/c
New York, 23rd American Watercolor Society, 3 w/c
New York Watercolor Club, charter member, probably exhibited, no records found.

1891 Age 45—Boston; summer, Newbury, Massachusetts
Exhibited:
Boston, 44th Boston Art Club, 3 w/c
New York, 24th American Watercolor Society, 3 w/c
New York Water Color Club, probably exhibited, no records found
Chicago, The Art Institute of Chicago, Spring Exhibit of Watercolors, 6 w/c
Worcester, Art Students Club, one-man show, 50 w/c
11th Annual Art Students Club, 3 w/c
11th Semi-Annual Art Students Club, 4 w/c

1892 Age 46—Boston; Century Building, address now listed as 3 Winter Street; summer, Monhegan Island, Maine
Exhibited:
Boston, Boston Society of Water Color Painters, 4 w/c
Chase's Gallery, one-man show, 30 w/c
46th Boston Art Club, 3 w/c
New York, 23rd American Watercolor Society, 4 w/c
New York Water Color Club, probably exhibited, no records found

1893 Age 47—Boston; summer, Monhegan; bought home for $325.00
Exhibited:
Boston, 48th Boston Art Club, 3 w/c, on jury
New York, 26th American Watercolor Society, 2 w/c
New York Water Color Club, exhibited w/c
Philadelphia, 62nd Annual Pennsylvania Academy of the Fine Arts, 2 w/c

1894 Age 48—Boston; summer, Monhegan; no longer listed as teacher, became U. S. citizen
Exhibited:
Boston, 50th Boston Art Club, 4 w/c
 Chase's Gallery, one-man show, 25 w/c
New York, 27th American Watercolor Society, 2 w/c
 New York Water Color Club, probably exhibited, no records found
Philadelphia, 63rd Annual Pennsylvania Academy of the Fine Arts, 2 w/c

1895 Age 49—Boston; summer, Monhegan
Exhibited:
Boston, 52nd Boston Art Club, 2 w/c, on jury
 Massachusetts Charitable Mechanics Association, 1 w/c
New York, 28th American Watercolor Society, 2 w/c

1896 Age 50—Boston; summer, Monhegan; did not return to Boston for winter, bought land with Frank Pierce
Exhibited:
Boston, 53rd Boston Art Club, 1 oil
 Boston Society of Water Color Painters, 6 w/c, vice president
 54th Boston Art Club, 3 w/c
 Third Jordan Gallery, 2 w/c
Chicago, The Art Institute of Chicago, Watercolors, Pastels, and Miniatures by American Artists, 1 w/c
 O'Brien Galleries, one-man show of w/c
New York, 29th American Watercolor Society, 3 w/c
Philadelphia, 65th Annual Pennsylvania Academy of the Fine Arts, 1 w/c
Poland Spring, 2nd Poland Spring Art Gallery, 5 w/c

1897 Age 51—Monhegan, bought fish house with Fred McClure
Exhibited:
Boston, 56th Boston Art Club, 3 w/c
 Fourth Jordan Gallery, 2 w/c
New York, 30th American Watercolor Society, 2 w/c
Chicago, O'Brien Galleries, one-man show of w/c

1898 Age 52—Monhegan
Exhibited:
Boston, 10th Boston Society of Water Color Painters, 6 w/c
 58th Boston Art Club, 3 w/c, Club buys A Squall Coming
New York, 31st American Watercolor Society, 6 w/c
 Macbeth Galleries, 4 w/c
Philadelphia, 67th Annual Pennsylvania Academy of the Fine Arts, 2 w/c
Poland Spring, 4 Poland Spring Art Gallery, 2 w/c
Worcester, Worcester Art Museum, w/c

1899 Age 53—Monhegan, returned to Boston for winter
Exhibited:
Boston, 11th Boston Society of Water Color Painters, 8 w/c
 60th Boston Art Club, 3 w/c
New York, 32nd American Watercolor Society, 3 w/c
Chicago, O'Brien Galleries, one-man show of w/c

1900 Age 54—Boston, summer Monhegan
Exhibited:
Boston, 62nd Boston Art Club, 3 w/c
Poland Spring, 6th Poland Spring Art Gallery, 2 w/c

1901 Age 55—Boston, summer Monhegan, bought land north of house
Exhibited:
Boston, 13th Boston Society of Water Color Painters, 11 w/c
 64th Boston Art Club, 2 w/c
New York, 34th American Watercolor Society, 1 w/c
Poland Spring, 7th Poland Spring Art Gallery, 1 w/c

1902 Age 56—Boston, summer Monhegan, closed studio in Boston, put furniture in storage
Exhibited:
Boston, 14th Boston Society of Water Color Painters, 13 w/c
New York, 35th American Watercolor Society, 2 w/c

1903 Age 57—Monhegan

1904 Age 58—Monhegan
Exhibited:
Boston, 16th Boston Society of Water Color Painters,
 11 w/c

1905 Age 59—Monhegan
Exhibited:
Boston, 17th Boston Society of Water Color Painters,
 10 w/c
 72nd Boston Art Club, 2 w/c

1906 Age 60—Monhegan, bought more land north of house
Exhibited:
Boston, 18th Boston Society of Water Color Painters,
 10 w/c

1907 Age 61—Monhegan

1908 Age 62—Monhegan, sold development plot
Exhibited:
Boston, 19th Boston Society of Water Color Painters,
 5 w/c

1909 Age 63—Monhegan, sold development plot

1910–13 Age 64–67—Monhegan

1914 Age 68—Monhegan
Exhibited:
Monhegan, Tercentenary Art Exhibit, w/c

1915–16 Age 69–70—Monhegan

1917 Age 71—Monhegan, sold development plot and fish
house

1918 Age 72—Monhegan

1919 Age 73—Monhegan
Exhibited:
Boston, 30th Boston Society of Water Color Painters,
 3 w/c

1920 Age 74—Monhegan, sold land in development

1921 Age 75—Monhegan
Exhibited: Philadelphia, Philadelphia Water Color Club,
 w/c

1922 Age 76—Monhegan

1923 Age 77—Monhegan, made out will, named Nellie H.
Colomy heir

1924 Age 78—Monhegan

1925 Age 79—Monhegan, died April 15

Two Letters

S. P. ROLT TRISCOTT's personal papers do not survive. Thus, these two letters provide a rare opportunity for the artist to speak in his own words about his life on Monhegan Island. The 1898 letter to New York art dealer William Macbeth is part of the Macbeth Correspondence in the Archives of American Art, while the 1908 letter to Triscott's close friend and fellow artist William Claus is found in the Jenney Collection at the Monhegan Museum.

Monhegan, Me.
Nov. 20, '98
William Macbeth, Esq.

Dear Sir,
I have sent you by express four of my water colors for your inspection. I hope they will meet with your approval and that you can find a sale for them in New York.

I enclose a price list which is well the same as I give Mr. O'Brien, who has sold a great many for me the last few years. I have spent the last two winters on this island and have painted out of doors every month of the year, and as you may not know the location of the place will mention that it is ten miles out at sea from the nearest point of the Coast of Maine so that I have a good chance to paint surf and show such as cannot be got on the mainland.

Should my paintings find favor with your customers I should be happy to take assignments with you to send some larger works in the future.

Yours very truly,
S. P. Rolt Triscott

Monhegan, Me.
Feb. 2, 1908

My dear Claus,
We have just had an old rip snorter of a storm that has torn everything all to pieces. The wharf has all gone up to the freight house, and Frank's tall chimney, brick and pipe, has bit the dust. Several lobster cars have disappeared. Geo. Smith's with $50 of lobsters on board was lost; all he found was the bow still attached to the moorings, and lots of dories sank, but were saved. The tide was so high that it came up to Walter's gate and to your cellar door, and one of the panes of glass in the window beside it is gone, but whether by the sea or flying shingles I don't know. A few shingles on the N. E. corner of your kitchen are ripped up, and I will get it fixed if I can get anybody to do it, which is very doubtful, as everybody has some repairing to do these days. I went through your house, and with the exception of some leaks around the windows, and a little ice on the floor, it was all right. As your kitchen is boarded up I did not go in there, so don't know its conditions. It has come in cold, and last night was quite severe, 34 below by your thermometer, but as it had blown off the nail, and a gallon or so of the spirit had run out, it may not have been correct. There is a man here lobstering from New Harbor who lives in his boat, which is an open one like Frank Winkipaw's [sic], and during the storm his stove in the cuddy was overturned, and when he turned out to see to it, found his boat half full of water, so it was bail, bail, all night to keep from sinking. A nice, pleasant, and agreeable way to spend a winter night at Monhegan. The mail service is the worst ever, not once a week on an average, and none on days that the old EFFORT would have made nothing of. What we shall do now without a wharf I don't know, but it will be bad for coal and wood, but fortunately I

have quite a good lot of both. Barstow has gone south. I fancy he must have had a cold time, and he got out just in season, as he would have frozen during the last storm. He said that one day he had to put the knives and forks in hot water before he could touch them. It is foolish to try to live in a house like that with no stove in the winter; but live and learn.

Steele's house is all framed and boarded, and will be probably ready in the spring. Soon time to plant now, and to let out your flakes for ——.

Regards to Myrich [*sic*] and Gooking.

Yours for the spring,

S. P. R. T.

Index

Page numbers in italics are for paintings or photographs.

RICHARD H. MALONE

BORN IN PITTSBURGH, PENNSYLVANIA, Richard H. Malone (1930–92) graduated from Pennsylvania State University, served as an officer in the United States Navy, and pursued a business career in Maine. During his retirement, Mr. Malone collected paintings by S. P. Rolt Triscott and conducted extensive research on his life, which resulted in the 1979 biographical essay included in this book. In 1983 Mr. Malone was the guest curator for "Monhegan: A Century of Art," an exhibition at the William A. Farnsworth Library and Art Museum in Rockland.

EARLE G. SHETTLEWORTH, JR.

A NATIVE OF PORTLAND, Earle G. Shettleworth, Jr., attended Deering High School, Colby College, and Boston University. At the age of thirteen, Shettleworth became interested in historic preservation through the destruction of Portland's Union Station in 1961. A year later he joined the Sills Committee which founded Greater Portland Landmarks in 1964. In 1971 he was appointed by Governor Curtis to serve on the first board of the Maine Historic Preservation Commission, for which he became architectural historian in 1973 and director in 1976. Shettleworth has lectured and written extensively on Maine history and architecture, his most recent publication being *Mount Desert Island*, which he co-authored with Lydia Vandenberg in 2001. He currently serves as chair of the Capitol Planning Commission and the State House and Capitol Park Commission.